MW00344554

IMAGES
of America

GOSHEN REVISITED

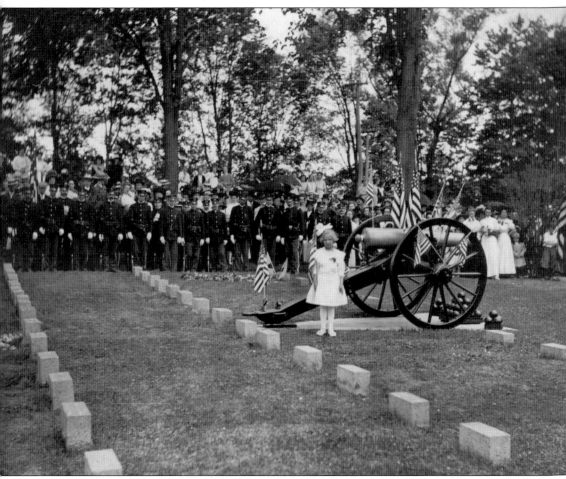

On May 31, 1917, during ceremonies following the dedication of the Everett Memorial in the Park Square, Florence Berrian is pictured among the veterans' graves in the Slate Hill Cemetery. Florence was born in Goshen in 1911 and died at 81 in 1992. (Courtesy of the Goshen Public Library and Historical Society.)

ON THE COVER: Following the dedication of the Everett Memorial in the Park Square on May 31, 1917, James "Jerry" Scott Jr. delivers the Gettysburg Address during Memorial Day ceremonies at the Soldier's Plot in Slate Hill Cemetery. Scott was born on March 9, 1863, and died in Goshen on December 31, 1939, at the age of 76. He was a member of the Village of Goshen Police Department and was chief of police in 1911. He was married to Annie B. McKee. (Courtesy of the Goshen Public Library and Historical Society.)

IMAGES
of America

GOSHEN REVISITED

Edward P. Connor

ARCADIA
PUBLISHING

Copyright © 2012 by Edward P. Connor
ISBN 978-0-7385-9252-7

Published by Arcadia Publishing
Charleston, South Carolina

Printed in the United States of America

Library of Congress Control Number: 2011944784

For all general information, please contact Arcadia Publishing:
Telephone 843-853-2070
Fax 843-853-0044
E-mail sales@arcadiapublishing.com
For customer service and orders:
Toll-Free 1-888-313-2665

Visit us on the Internet at www.arcadiapublishing.com

This book is dedicated to all who volunteer, especially the men and women of our armed forces and the Goshen fire departments: Cataract, Dikeman, and Minisink, and the Goshen Volunteer Ambulance Corps. This book is also dedicated to and in memory of my uncle Lawrence P. Zabachta.

CONTENTS

ACKNOWLEDGMENTS

Goshen is fortunate to have had many dedicated historians who have left many published articles and books, especially Elizabeth Sharts, Mildred Parker Seese, Harold Jonas, Samuel Eager, Henry Pomares, and Michelle Figliomeni. I would like to thank them for leaving such an extensive paper trail. Also, a thank-you goes to the Cataract Engine & Hose Company for the use of their 150th anniversary catalog in compiling information on the fire department chapter. One of the good things about writing a book like this is having the opportunity to hear so many stories from so many people. Thank you to everyone for taking the time to convey his or her memories of Goshen. A thank-you also goes to Kit Wallace for sharing her extensive knowledge of Goshen history. The Goshen Public Library and Historical Society is a treasure trove of Goshen's past. Special thanks must go to Ann Roche, whose knowledge and dedication to Goshen's history is very much appreciated. Thank you to her for her help and patience while I was researching Goshen's history in the Sharts' Room of the library. Thanks must also go to Diane Petit, who scanned all the photographs. Photographs of all the houses are courtesy of the Orange County Historian's office's collection, unless otherwise noted. Other photographs are from the Goshen Public Library and Historical Society, the Village of Goshen's Historian's Collection, my personal collection, and others as noted in the text.

INTRODUCTION

Goshen Revisited is the second volume on Goshen in the Images of America series. Goshen is located in the heart of Orange County, New York, about 60 miles northwest of New York City, and serves as the county seat. A courthouse, built in 1738, cemented Goshen's role as a political and governmental center.

Settled in 1714, Goshen was part of the 1703 Wawayanda Patent, a large tract of land granted by the English to John Bridges and others, after Bridges acquired the title from the Native Americans. While Goshen is the center of county government, it is also known for its many fine Victorian homes, old farming tracts, and rich history of harness racing. With the arrival of the railroad in 1841, Goshen was able to experience a boom both in commerce and building. Farmers were no longer required to transport their produce to Newburgh, making their way down the Hudson River to the city, but could drive to the village of Goshen, and the train could have their products in the city in a matter of hours. After 1841, the majority of the village's large homes were built and the commercial center moved from the Lawyers' Row area of Main Street farther west toward the Erie Railroad Station, now used as the building for the police department.

In the early days of the community, when farmers would come into the village, they would test the speed of their horses by racing up and down Main Street. As this developed into a sport over the years, a track was created. Harness racing became a favorite pastime. With the creation of the mile track, Good Time Park, Goshen eventually became home to the Hambletonian. The Hambletonian is the major race event in harness racing. Goshen hosted the Hambletonian from the mid-1930s to the 1950s. During this time, Goshen was the smallest community in the country with two active racetracks devoted exclusively to harness racing. Because of this sport and Goshen's close proximity to New York City, Goshen became a travel destination. During the summers, guests would arrive on the trains and fill the local hotels and boardinghouses.

It is hoped that this volume will give readers the opportunity to look back to this time to see the buildings and some of the people that made Goshen a unique and special place.

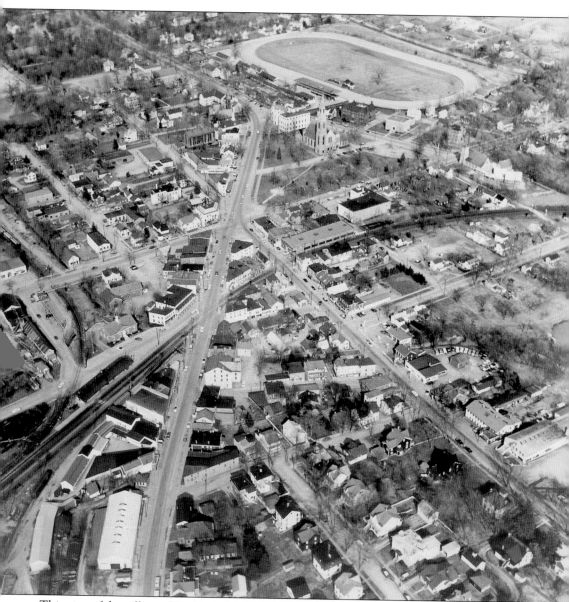

This view of the village of Goshen, photographed from the air sometime during the 1960s, shows a number of buildings that no longer exist. The old Erie Railroad tracks and the Erie Railroad branch line to Montgomery can be seen crossing through the village. West Main and Main Streets run the length of the photograph up to Historic Track in the distance. (Courtesy of the Goshen Public Library and Historical Society.)

One

THE VILLAGE

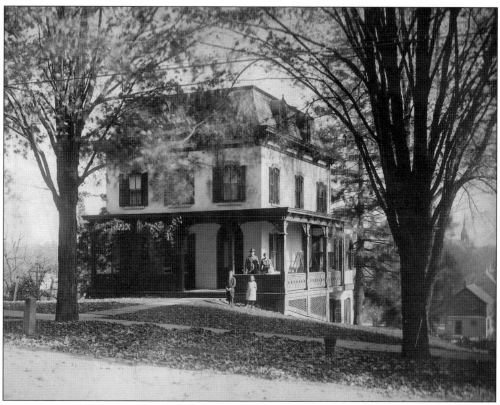

Built around 1860, this mansard-roofed, brick Victorian on Murray Avenue was the home of J.S. Mapes. Around 1903, it belonged to J.R. Weir. Pictured here around 1915, the Dolan family poses in front of the house. The young girl on the lawn is Catherine Dolan, who would later marry William S. Prial. Prial purchased the Chevrolet Oldsmobile dealership in Goshen from James Stanton in 1953. The house has been the Boyle family home for a number of years. (Courtesy of the Boyle family.)

This photograph shows Murray Avenue, looking toward Erie Street. Robert Weir owned the house nearest in the foreground. He bought the property in 1883 from Edwin Dikeman, a local druggist, and built the house in 1889. Dikeman entered the pharmacy business in 1895 in the pharmacy that was started by his father in 1864 in the building that is now the site of Maureen Mullany's Pub on West Main Street. (Author's collection.)

This photograph of tree-lined Murray Avenue was taken looking west almost at the corner of Murray Avenue and Erie Street. At the time, Murray Avenue was a dirt street and all the maple trees were of the same age and size. Garr Institute, on the left, opened in 1904 and served as a Catholic school until John S. Burke High School was built on Fletcher Street in the 1960s. (Courtesy of the Goshen Public Library and Historical Society.)

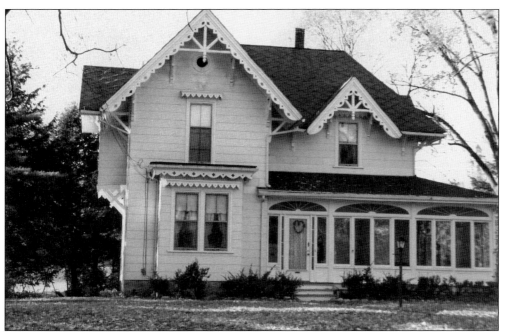

Built in 1871, this house on the corner of Murray Avenue and Erie Street belonged to Robert H. Berdell, owner of the Interpines. Other owners were the Cuddeback family, and around 1900, George Ivory. Anna Dexter also called this home later in the century. In 1925, Edna and Jesse Parsons bought the house. It remained in their family until 1987, when the Jankowski family purchased the house. (Courtesy of the Jankowski family.)

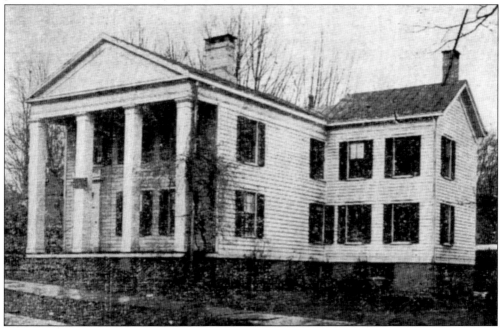

Located on North Church Street, this 1843 Greek Revival home is similar in style to a few other homes in the village, especially one on South Street. It belonged to F.A. Crane in the 1870s, and later to Edgar Redfield. In the 1970s, Russell Sanford lived here.

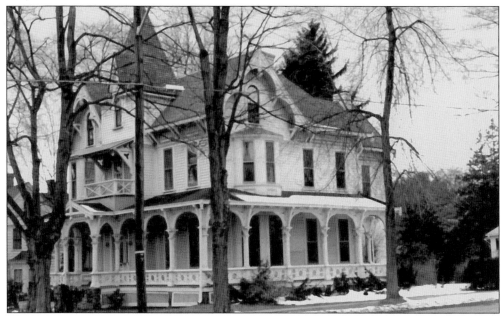

This Victorian on the corner of Murray Avenue and North Church Street belonged to H.H. Smith shortly after it was built. Over the years, it was the home of the Wyker, Seely, Grimes, Church, and O'Donnell families.

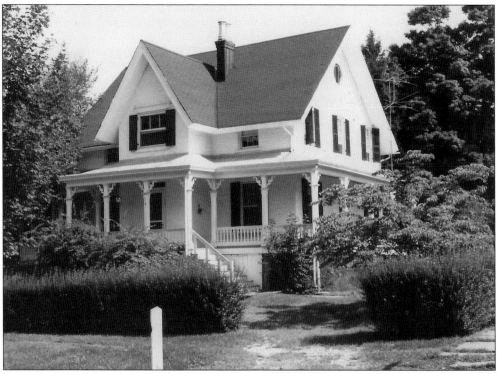

Situated on the corner of North Church Street and Murray Avenue, this brick home belonged to the Roe family in the 1800s. Later in the century, the Schoonmaker family resided here from the mid-1800s into the early 1900s. In the 1960s, the Seely family called it home.

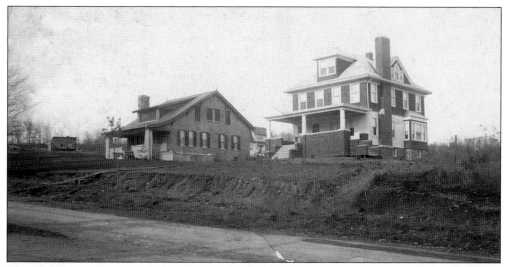

This photograph shows two houses on North Church Street, dating to the early 1920s. The house on the left was the home of Arthur Decker in the 1950s, and later, the Lloyd family. The house on the right was a Thompson family home for some time. (Courtesy of the Village of Goshen Historian's Collection.)

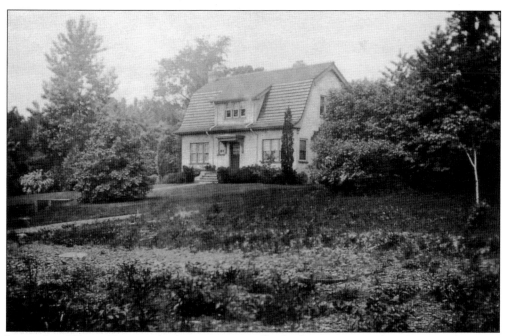

Located on Wisner Terrace, this house is reportedly the first constructed on the street by Frank Drake in 1916. It later belonged to the Rombousek family. (Courtesy of the Village of Goshen Historian's Collection.)

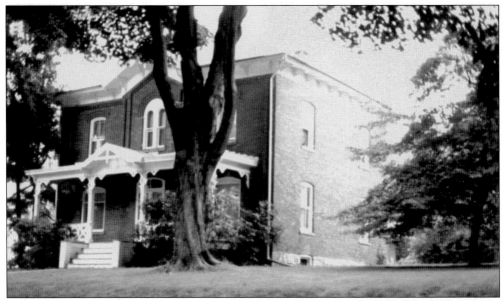

This brick Victorian sits along Wickham Avenue at the top of Grand Street. It was the home of John Dayton, a shoemaker who had a business on West Main Street. The house was in the Dayton family for many years. It has been the home of the Cullen family in recent times.

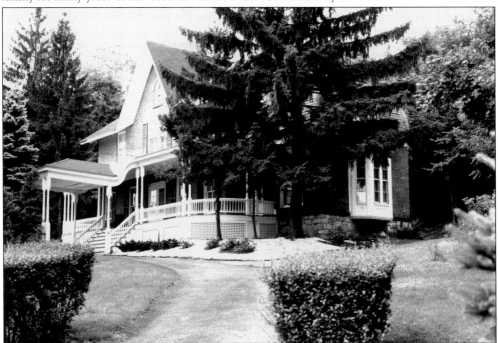

William Sayer came to Goshen in 1837 and became a clerk in a store. In 1840, he became a partner in the store Reevs and Sayer. In 1846, he bought out Thomas T. Reevs, who became a cashier in the Bank of Orange County. In 1847, William began building houses in Goshen. This c. 1850 brick house, located on Greenwich Avenue, once overlooked Good Time Park, the mile-long track hosting the Hambletonian. The building now contains offices. The property where this house now sits once had a two-story stone house before the present structure was built.

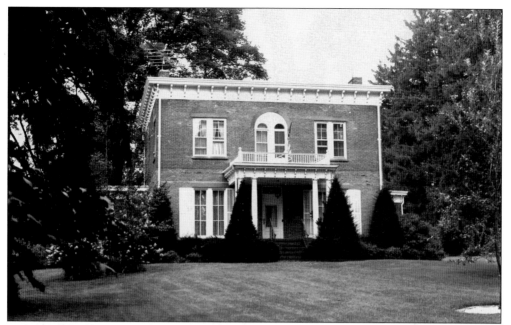

Owned by J.K. Payne in 1875, this brick Federal home on Golden Hill Avenue was built between 1850 and 1860. An early drawing on a Goshen map shows the house with a cupola on the roof and a porch extending along the front of the house. Over the years, the Goldsmith, Cathy, and Post families have lived here.

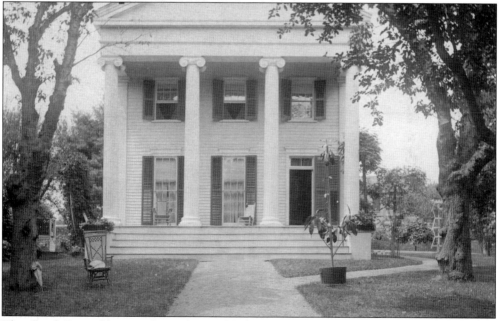

This Greek Revival house is located on Golden Hill Avenue. This photograph shows the house before the wing was added to the right side. Asa Jansen purchased the land in 1842, and construction most likely began soon after. The house also belonged to the Merritt family for many years. Joseph Merritt was born in 1855 in Mount Kisco, New York. Joseph was president of the Goshen National Bank from 1914 until his death in 1954. (Courtesy of Kit Wallace.)

John T. Jansen purchased this property on Golden Hill Avenue and North Church Street in 1843, where he built this house. In 1875, Victorian elements were added. The house was in the Shelton family in the late 1800s. It was purchased by Aaron Van Duzer Wallace in 1898. (Courtesy of the Village of Goshen Historian's Collection.)

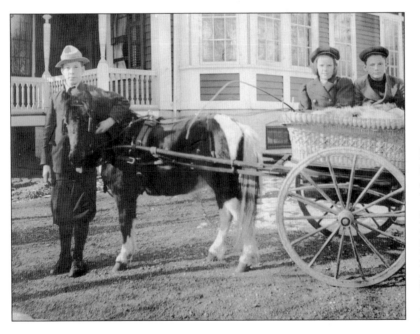

Posing with their pony and cart outside the Wallace house on Golden Hill Avenue are Henry Merritt and Lucie and Van Duzer Wallace. (Courtesy of Kit Wallace.)

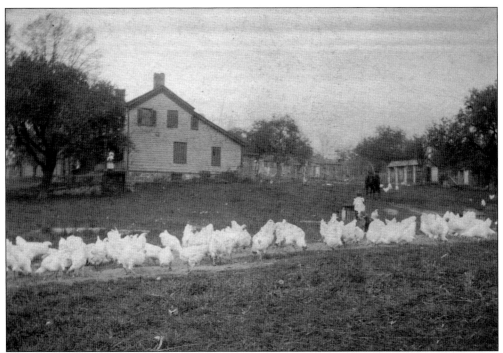

This photograph, probably taken between 1896 and 1902, shows a house located between Murray Avenue and Montgomery Street that was part of the Willow Crest Poultry Farm. W.M. Haskell was the proprietor of the farm, and J.E. White was the manager. (Courtesy of the Goshen Public Library and Historical Society.)

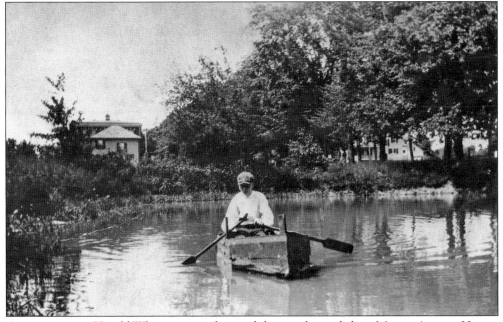

As a young man, Harold White rows on the pond that was located along Murray Avenue. Houses now occupy this area. The former Garr Hall, now an office building, can be seen in the distance. (Courtesy of the Goshen Public Library and Historical Society.)

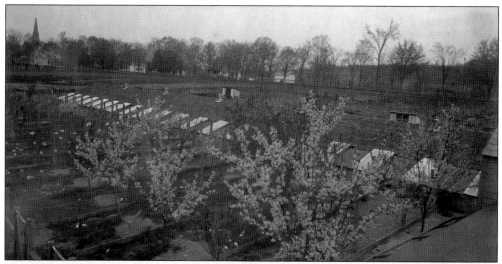

The Willow Crest Poultry Farm's chicken houses and poultry yards show what an extensive operation the farm maintained. Murray Avenue runs along the top of the photograph. The steeple of St. John's Church can be seen in the distance on the left. (Courtesy of the Goshen Public Library and Historical Society.)

This is a photograph of the Willow Crest Poultry Farm looking north. Houses on the upper end of Murray Avenue, still there today, can be seen to the right. The poultry houses are in the center, each one with a yard 40 feet wide by 125 feet long. The farm was known for raising White Wyandottes. Advertising for the farm stated, "White Wyandottes are vigorous and hardy, and are the best fowl we believe that there is bred, either for the fancy or practical uses." (Courtesy of the Goshen Public Library and Historical Society.)

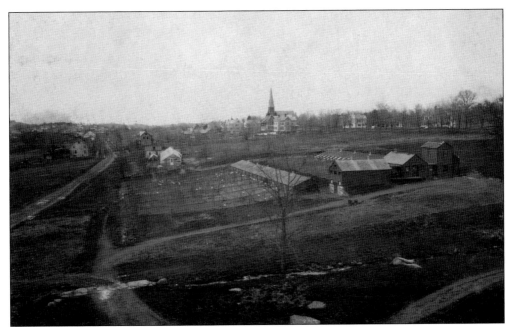

This photograph was taken from the roof of the Montgomery Street carriage house that served the Interpines estate, which once occupied the site of the Orange County Government Center. The carriage house was used by the Willow Crest Poultry Farm during its time of operation. Montgomery Street is to the left of the photograph, which faces west toward Erie Street. The steeple of St. John's Church on Murray Avenue can be seen in the distance. (Courtesy of the Goshen Public Library and Historical Society.)

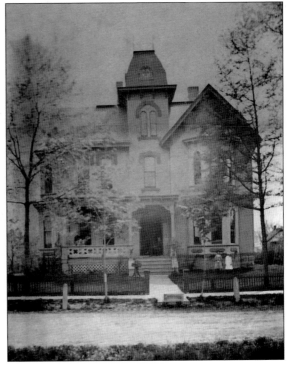

This brick Victorian is located along South Church Street, across from the park. Floyd and Christine Cowdrey Reevs, who owned a store on West Main Street, built the house in 1876. Floyd Reevs was born in Westtown in 1837. In 1866, after the death of his father, he formed the partnership of Reevs and Kelsey. He died in 1898. He and his wife had two daughters. Descendants of the Reevs, the Makuen family, still reside in the house. (Courtesy of Floyd and Teresa Makuen.)

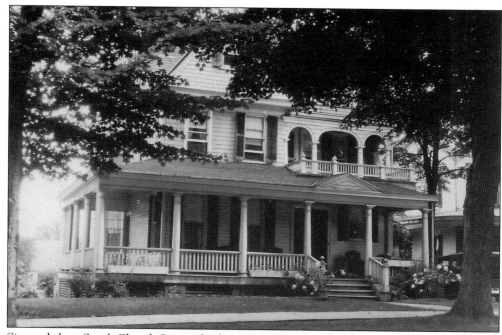

Situated along South Church Street, this house was owned by the Hogue family soon after it was built between 1870 and 1880. It was also owned by Charles G. Elliott, president of the Goshen National Bank. Born in Goshen in 1837, Elliott also served as county clerk, town board member, and treasurer of the village. The house also belonged to Doctor Leichter and his wife, Claire, as well as Thomas and Gertrude Lee. In recent times, it has been the home of the Cirigliano and Donovan families. (Courtesy of the Village of Goshen Historian's Collection.)

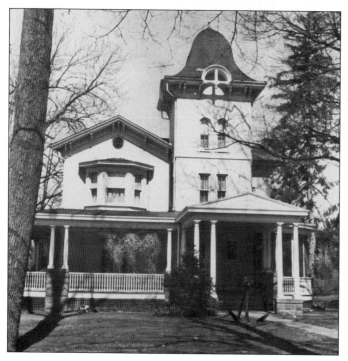

Nathaniel Van Sickle, who built some 40 homes in Goshen, built this stately home on South Church Street. James Galway, who owned Parkway Farm on Parkway, was an early owner. In the 1930s, it was the home of noted horseman Walter R. Cox and his wife, Emma. Cox was a trainer for William Cane at the Good Time Stable, located at Goshen's mile track, Good Time Park. Known as the Anchorage, the house was also owned by prominent and active village residents Grace Lee and Lester Roosa.

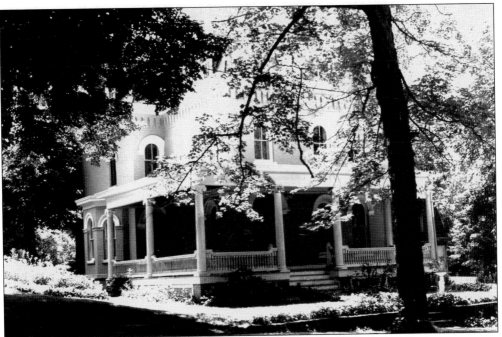

Aaron Van Duzer built this brick, mansard-roofed Victorian along South Church Street for one of his eight daughters, Fannie Cooper. Around the early 1900s, the house was owned by the Horton family.

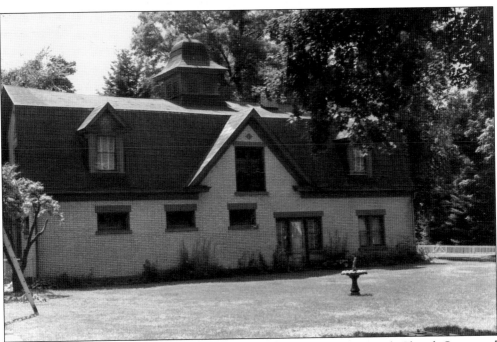

This unique, c. 1912 brick barn adjacent to the Van Duzer house on South Church Street and Phillips Place was built by Ira Ryerson. Its location near the Historic Track made it convenient to stable horses. It also served as a meeting place for the local grange.

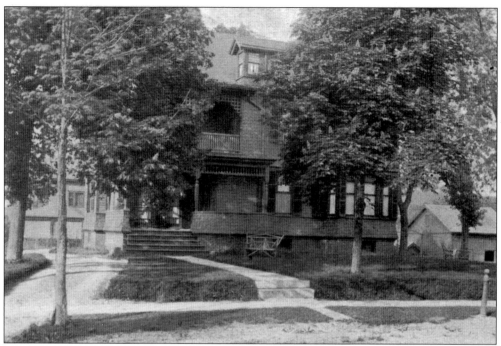

Located on the corner of South Church Street and Parkway, this house was built as the Presbyterian manse or parsonage in 1886. It replaced an earlier house on the site. On July 7, 1886, the congregation voted to build a home for their pastor. The house was completed in March 1887.

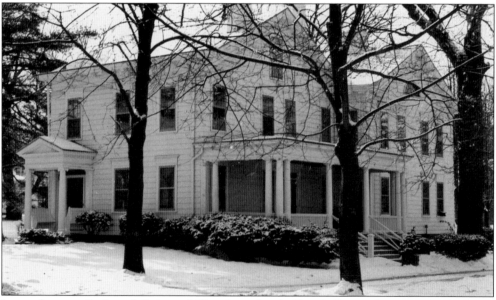

Located next to St. James's Episcopal Church on South Church Street, this was once the home of Benjamin F. Edsall, born in Goshen in 1812. He was president of the Goshen Savings Bank and vice president of the Goshen National Bank. He also served as county treasurer. Edsall was a delegate to the Democratic Convention in 1860 that nominated Stephen Douglas. He was also president of the village from 1860 to 1864. Over the years, the house was home to the Holstead, Conklin, Rabidoux, and Novak families.

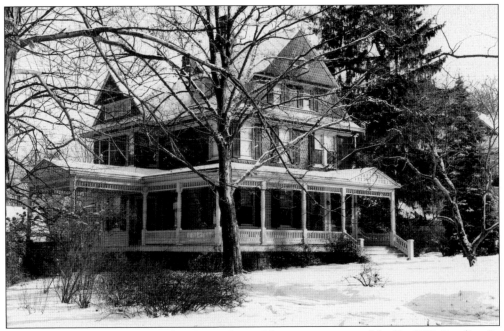

Built between 1880 and 1890, this Green Street Victorian was owned by Dr. D.T. Condict. In the 1920s, it was the home of Florence and Harriet Houston and their brother Harold, who owned the Van Duzer farm on the Florida Road/Route 17A. The sisters lived in this house all of their lives.

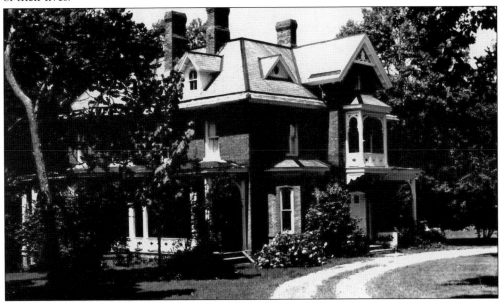

This stately brick house on the corner of Phillips Place and Green Street was once the home of Jason Wells Corwin and his wife, Sarah Howell Corwin, who owned a hardware store in Goshen. Corwin came to Goshen in 1846 and was president of the village from 1873 to 1874. The house was owned at various times by the Conklin, Brinkley, and Ottaway families. In 1968, it was the location for the filming of the movie *Winter of the Witch*, starring Hermione Gingold, George M. Cohan Jr., and Burgess Meredith.

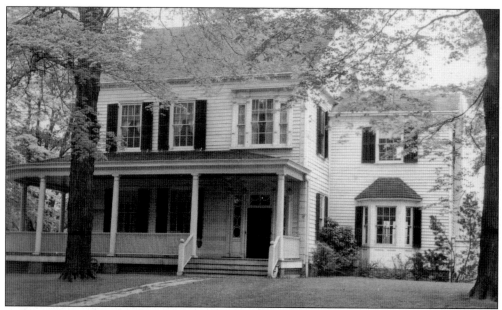

Built by John Hurtin in 1802, this house sits on the corner of South and South Church Streets. The house was purchased in 1826 by Issac Van Duzer. His descendents, the Gott family, lived in the house until 2003. (Courtesy of the Village of Goshen Historian's Collection.)

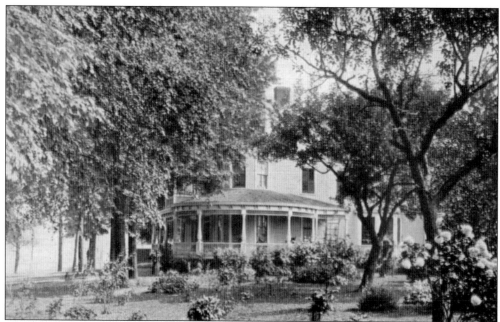

Located on Parkway, across from Historic Track, Parkway Farm has been significant in the development of the track. Over the years, it has had a number of owners, including David Wescott, the Edsall family, and Nathaniel Van Sickle, who bought it in 1854 and sold it to James Galway in 1873, who then sold it to veterinarian Doctor Pooler. It was also the home of Senator McCardy in the early 20th century. In recent times, the De Vine family has lived here for many years. (Author's collection.)

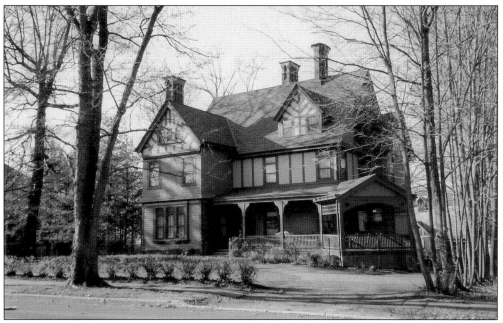

This Victorian, located on South Street, belonged to the Duryea family for many years. Henry C. Duryea was born in Goshen in 1847. In 1862, he enlisted in the 168th New York Volunteers. After the Civil War, he became a partner in the law firm of Duryea, Bacon, and Duryea. He later opened his own law firm. He was 59 when he died in August 1906. In the 1970s until the early 2000s, the house belonged to the Koziara family. (Author's collection.)

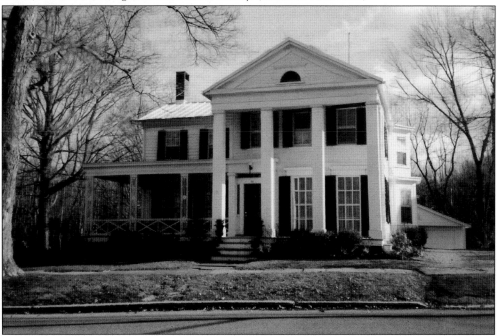

This Greek Revival home was built on South Street around 1841 and was owned by the Lockwood family. It later passed to Francis Murray, and in the 20th century, it became the home of the Chamberlain, Pardy, and McDermott families. (Author's collection.)

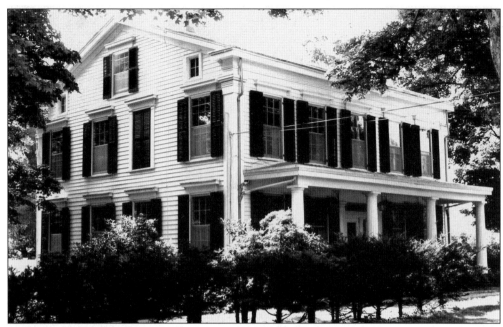

This c. 1850 Greek Revival home belonged to the Grier family. Before building this South Street home, the Grier family lived on Main Street in the house next to the Music Hall and former Masonic Temple. Grier was a close friend of William Seward, who reportedly visited here. It was the home of Guy Stephenson in the 1960s.

Alfred B. Post, who came to Goshen in 1824, owned this house on South Street in the 1800s. Thomas Finan, who purchased the house, was born in Tarrytown on March 22, 1850, and came to Goshen in 1872. He opened a grocery business on Greenwich Avenue, and after a few years, opened a hotel in the same building. He also owned a coal and feed business, a brickyard, and an icehouse off of Green Street. He died in February 1915. The house remains in the Finan family.

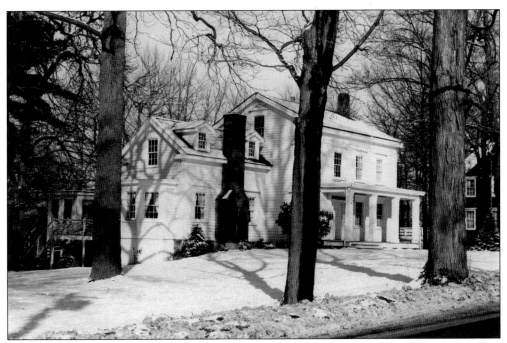

In the late 19th century and early 20th century, this Federal style house on South Street belonged to Orange County clerk W.E. Mapes. In the mid-20th century, the Phillips family resided here. It later became the home of the Degan family for a number of years.

Along South Street sits the home that once belonged to Charles W. Coleman and his wife, Mary Louise Hoyt Coleman. Coleman was president of the village from 1877 to 1878. The Rotan family owned the house for many years; the Mirro family has owned it since the 1980s.

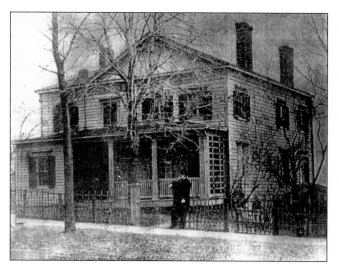

This house once belonged to Dr. Joshua Ward Ostrom, who came to Goshen in 1839. He was actively involved in the creation of the Middletown State Hospital. He also served as a trustee and president of the village. His first wife was Charlotte Gedney, a first cousin of Pres. John Quincy Adams. They had five children. Charlotte Ostrom died in 1879 and Doctor Ostrom later married Emma La Gar. From the 1960s to the 1980s, the Meehan family resided here.

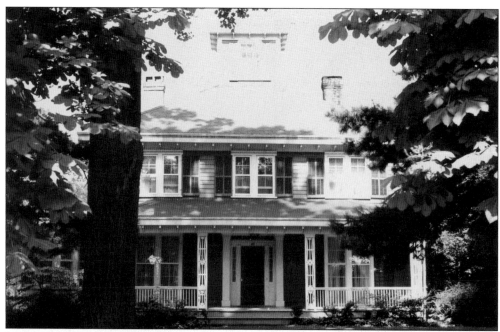

J.S. Hopkins lived in this South Street house in the 1800s. In the late 1800s and early 20th century, Nathaniel Johnson Kelsey owned the house, which he called Pinehurst. Kelsey was born in Goshen in 1834. He became a clerk in the Charles W. Reevs store on West Main Street. Reevs died in 1866, and the firm of Reevs and Kelsey was formed with Floyd H. Reevs. The Brinkley, Beshore, Van Saun, and Degan families later occupied the home.

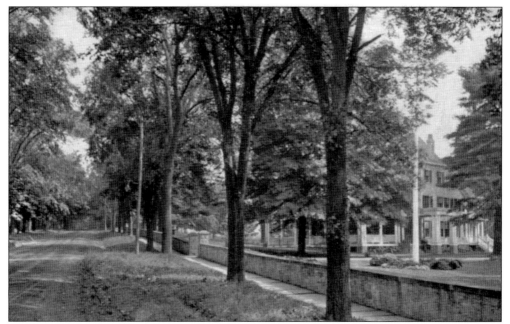

This is a photograph of South Street looking east before the street was paved. In the late 1800s and early 1900s, George C. Miller owned the house to the right, known at that time as Lone Oak. His wife was Mary Wisner. The Huben family lived here in the 1970s. (Author's collection.)

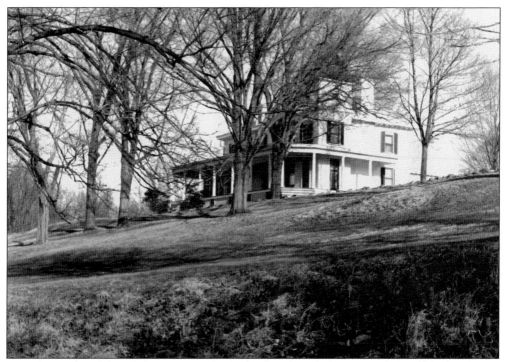

Located on South Street on the village and town border, this home belonged to the Love family for many years. In the late 1800s, it was the Van Nuyse home, known as Grand View. In the early 1900s, the Osborn family owned the house.

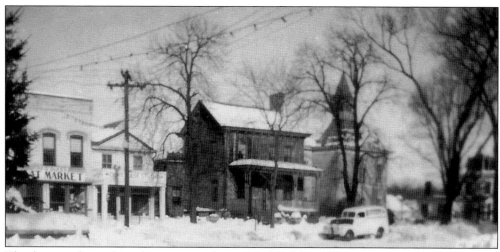

This house is located on the square at the corner of Webster Avenue and Main Street. It was the Jackson family home for many years. Charles Jackson, born in 1807 and died in 1876, was Goshen's postmaster. In the 20th century, it was the home of Bessie Jackson and her brother Harold Jackson. The Goshen Town Hall is to the right. (Courtesy of Adele Coates.)

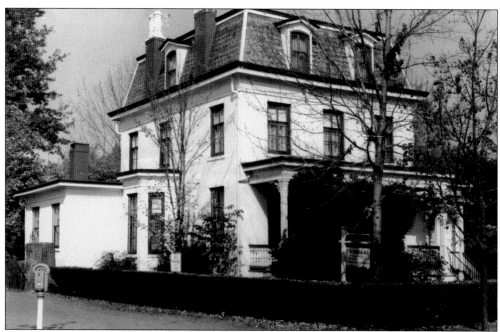

This mansard-roofed, brick Victorian on Webster Avenue is located next to the Goshen Town Hall. It was owned by Dr. Ralph McGeoch in the first decades of the 1900s. His wife was Sarah Westcott Coleman. They were married in 1897. He retired at 76 years of age in 1943 and died the next year. In the mid-1960s, it was the home and office of Dr. Elias Young. Today, offices occupy this home.

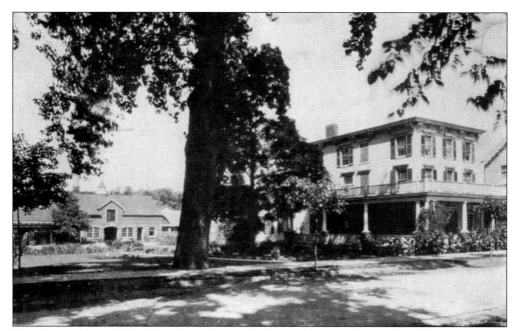

The former home of Dr. John F. De Vine and his wife, Rose, is located on Webster Avenue. Doctor De Vine was a well-known veterinarian. They had a daughter, Gertrude De Vine. (Author's collection.)

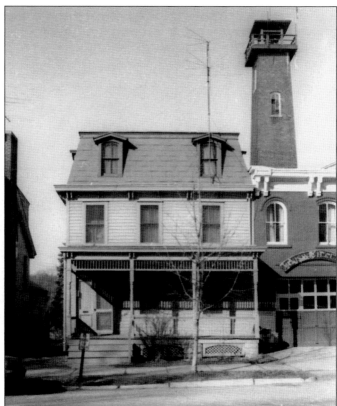

This house on Main Street, next to the old Minisink and Cataract firehouse, was home to the Bishop family in the late 1800s into the early 1900s. It later became the Jonas family home after they moved from North Church Street. Mendel Jonas came to Goshen in 1883 from Salem, New York. He owned a successful clothing store on West Main Street. His son Henry joined him in the business and the store became known as M. Jonas and Son. Mendel's grandson was Harold Jonas, a well-known Goshen historian.

This brick house is located next door to the Goshen Public Library and Historical Society on Main Street. It was owned by the Wallace family from the mid-1800s to the early 1900s. It was also owned by the Knight family, as Mrs. Knight was Mary Wallace. More recently, it was the home of Merel Scheidell, a prominent local attorney. The house is currently used as a law office.

Situated on the corner of Main Street and Orange Avenue, this brick 1873 Victorian was once the Ackerman home. Cornelius Ackerman also built the Post-Finan house on South Street and the Presbyterian parish house on the corner of South Church Street and Parkway. The house was purchased by Wilmont P. Thompson, a feed dealer in the 1890s. In 1905, John R. Townsend, a member of the Orange County Hunt Club, rented the house. In 1933, it was sold to Christopher Pope, Thompson's son-in-law. Over the years, it has passed to the Fisher and St. Lawrence families.

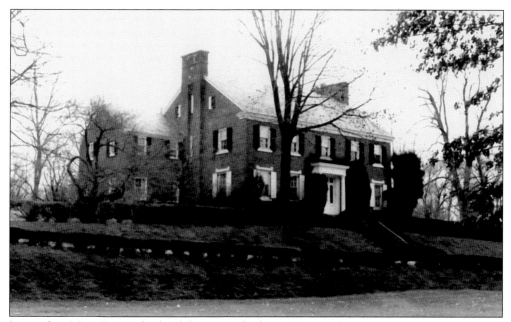

Located on Main Street, this brick house was built in 1926. On this site was Congressman Henry Bacon's home, known as the Pines. That house was destroyed by a fire in 1916. The rear wing of the Pines was an early Goshen inn. William Wickham purchased the inn in 1790 and converted it to a residence. Dwight Hall built the present brick house that later became the home of the Lippincott family for many years.

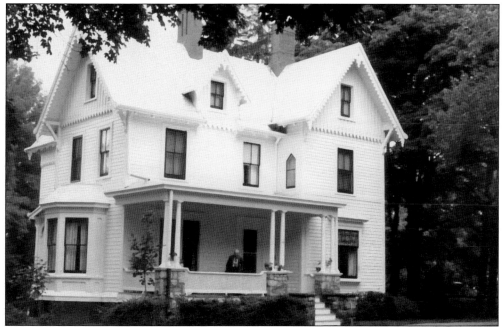

Marshall Swezey is standing on the front porch of his house on the corner of Main Street and Scotchtown Avenue. Originally built by the Murray family, the house has been in the Swezey family since the late 1800s. In the early 2000s, the house was moved closer to the street and has been used as offices.

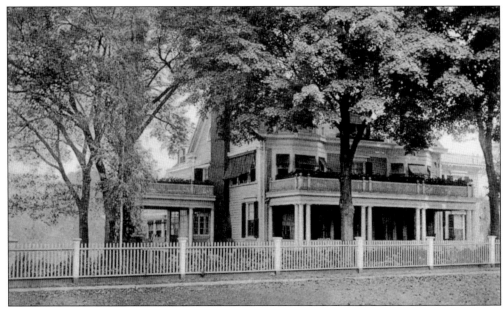

This longtime home of the Alloway family was known as the Birches. Located on Main Street, it was known for its extensive gardens while owned by the Alloway family. In the late 1800s, the Sharpe family resided here. It has been an apartment house for a number of years. (Author's collection.)

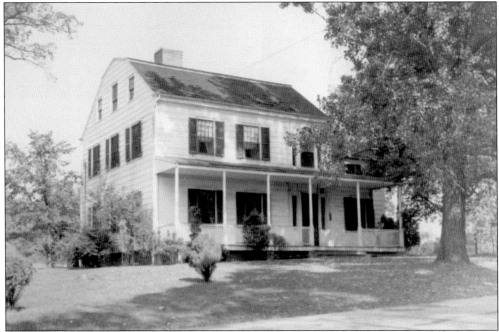

The house that once belonged to the Carpenter family is located at the junction of Main Street and Sarah Wells Trail. Built around 1724, it was enlarged prior to the Revolutionary War. Jeromus Johnson married Mary Carpenter in 1802. The junction of Main Street and Sarah Wells Trail, known as Carpenter's Corners, then became known as Johnson's Corners, a name that is hardly heard of today.

Two

DOWNTOWN

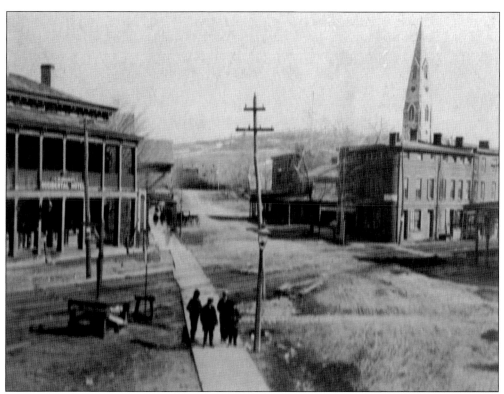

This photograph shows West Main Street looking east toward the square. To the left is the Occidental Hotel that was destroyed by a fire in 1983. The platform to the left was used as a mail pick up for passing trains. To the right in the distance is the wooden building that predated the current Howell's Café brick building. Note that West Main Street is dirt with wooden sidewalks, and a gas lamp is visible in the foreground. (Courtesy of the Village of Goshen Historian's Collection.)

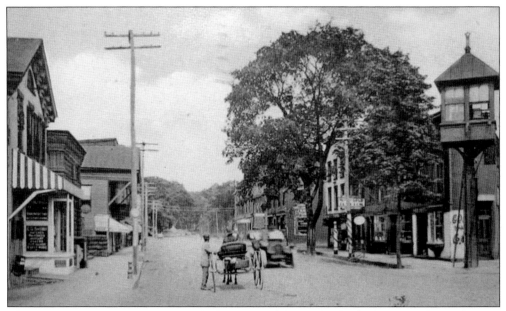

This photograph of West Main Street looking toward the square shows the railroad gate tower on the right. The building that is now Baxter's Pharmacy is on the left. The photograph is unique in that it shows both a horse and buggy and an automobile. (Author's collection.)

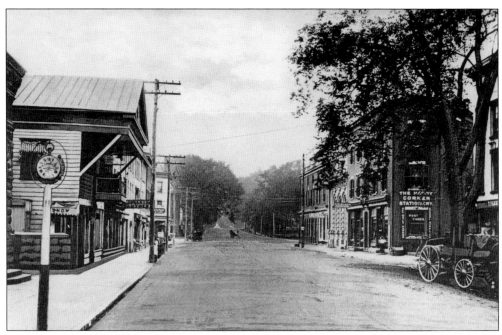

A rather quiet West Main Street looking toward the square shows the building on the left that was later to become the Grand Union and after that the Goshen Hardware. On the right, the Handy Corner Stationery store is today Howell's Café. (Author's collection.)

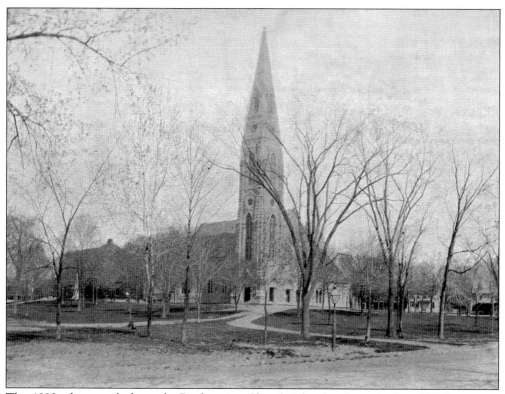

This 1890s photograph shows the Presbyterian Church. The church was built in 1871 from stone mined at the Dutchess Quarry off the Florida Road/Route 17A. (Courtesy of the Goshen Public Library and Historical Society.)

This photograph of St. James's Episcopal Church was taken before the installation of the Wisner Monument in 1897. The church was built in 1853, replacing an earlier, wooden church. The photograph shows the steeple before the current Gothic style top was added. Note that South Church Street and Park Place were dirt streets at the time. (Courtesy of the Village of Goshen Historian's Collection.)

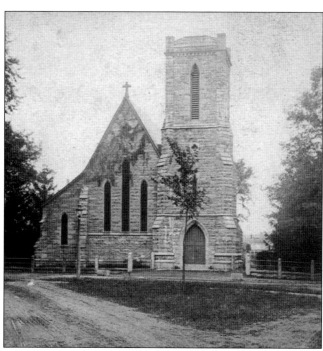

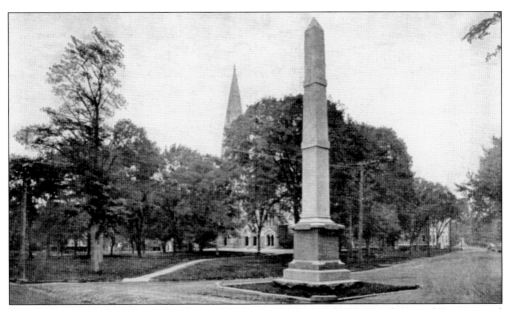

Installed in 1897 and dedicated to Henry Wisner, a member of the First and Second Continental Congress, this monument sits at the intersection of South Church Street and Park Place. Wisner was elected as a New York delegate to the Continental Congress from 1774 to 1777. He also served as a member of the New York state senate from 1777 to 1782. He voted for the Declaration of Independence, but was called away before the signing. Born in Florida, New York, in 1720, he died in Goshen in 1790. (Courtesy of the Village of Goshen Historian's Collection.)

The last remaining cottonwood tree is seen in the park shortly before it was removed. The tree can be seen in the earliest photographs of the village square. Up until the 1980s, there were at least five large cottonwood trees surrounding the square. In the spring, the air around the square would be filled with their white, fluffy seeds. (Author's collection.)

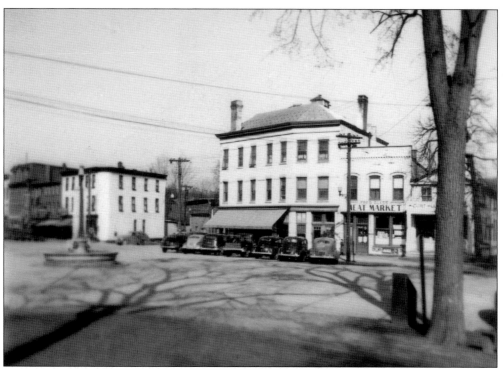

This 1940s photograph of the square shows the Seely Block, which was the location of Dayton's, and later, Julia Maney's department store. Fred Glass's Meat Market is to the right. Note the cars parked facing the curb, impossible today with the increase in traffic. (Courtesy of Adele Coates.)

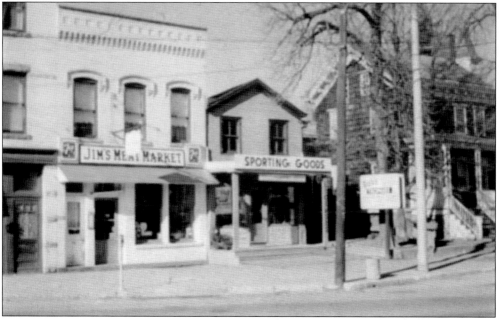

Following the death of Fred Glass, the Meat Market became Jim's Meat Market, owned by James Scesa. The sporting goods store next door was owned by Mayor Robert J. Rysinger. (Courtesy of the Village of Goshen Historian's Collection.)

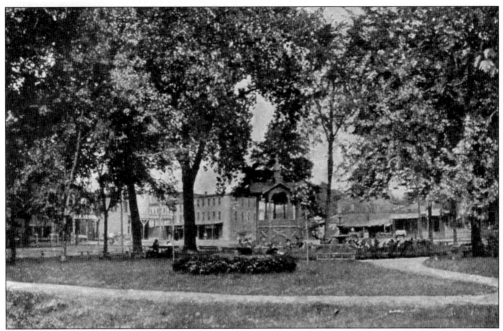

This c. 1890 photograph of the park shows the second bandstand erected in 1876. This photograph is unique in that it was taken from inside the park looking out to the square and the business district. The buildings to the right appear to be earlier structures than the brick buildings that are on the site today. To the right of the bandstand is the fountain, installed in 1886. (Courtesy of the Goshen Public Library and Historical Society.)

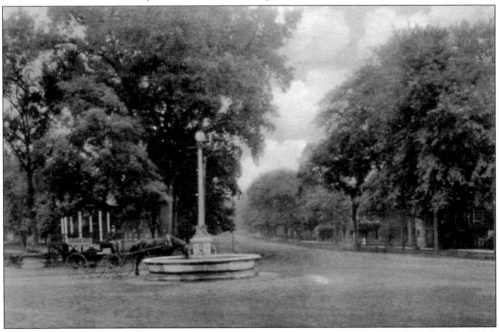

This bucolic image of Harriman Square was taken sometime between 1911, when the Harriman Memorial Fountain was installed, and 1917, when the Everett Memorial replaced the 1876 bandstand seen here. South Church Street is visible to the right. (Author's collection.)

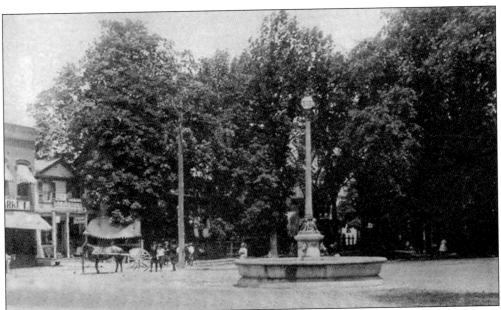

This is a photograph of the Harriman Memorial Fountain, erected in 1911 in memory of Edward H. Harriman. Tree-shaded Webster Avenue is directly behind the fountain. The wooden building on the left was the Doremus photography studio. In the 1960s, it was the location of Bob's Sports Shop. The building was demolished in the 1970s. (Courtesy of the Village of Goshen's Historian's Collection.)

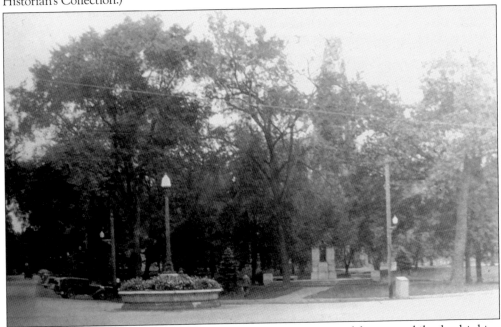

With the passing of the horse-drawn wagon and the increasing use of the automobile, the drinking trough on the square became obsolete. The Harriman Memorial Fountain was then filled with plants and flowers. For many years, retired police chief Stanley Golemboski maintained and watered the plantings. In 1999, it was restored to a working fountain. (Courtesy of the Goshen Public Library and Historical Society.)

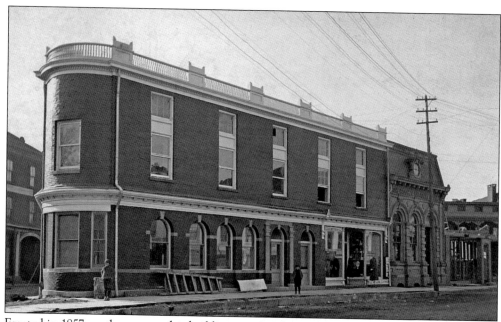

Erected in 1857 on the square, this building was first known as Washington Hall, then later as the Fletcher block. In 1899, Ben Levinson's clothing store was established in the storefront on the right side of the building. Levinson retired in 1941. George J. Strong took over the business and was there until the Goshen Savings Bank expanded on the site in 1952. (Courtesy of the Goshen Public Library and Historical Society.)

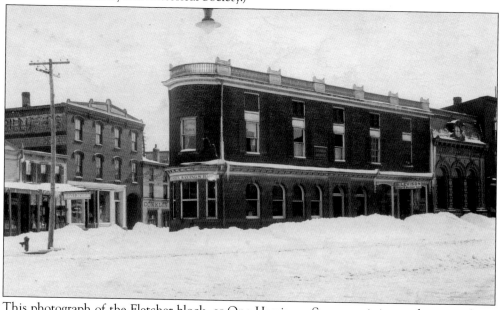

This photograph of the Fletcher block, or One Harriman Square as it is now known, after a snowstorm, shows the Goshen Savings Bank in the front portion of the building with Levinson's Clothing Store to the right. The dentist office of Dr. Edwin Parker was upstairs. Doctor Parker lived on South Street. To the left is Greenwich Avenue, Seely Bakery, and Conklin's Feed and Grain store. Also visible is a sign for Rudolf Rickborn, who owned a grocery store. (Courtesy of the Village of Goshen's Historian's Collection.)

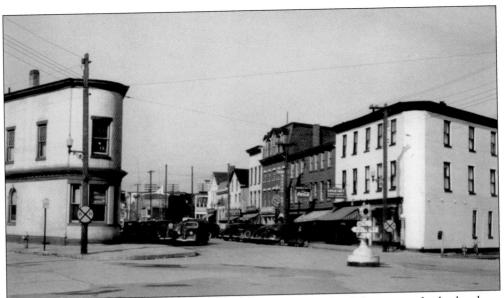

West Main Street is thriving in the 1940s. On the right side of the street, the barbershop, Robinson's Stationery Store, and the Pantry are followed by the Grand Union and the A&P. An early traffic signal in the middle of the square has signs directing traffic to Middletown and Route 17. Other than the cars facing into the curb, not much has changed in comparison to today. (Courtesy of Adele Coates.)

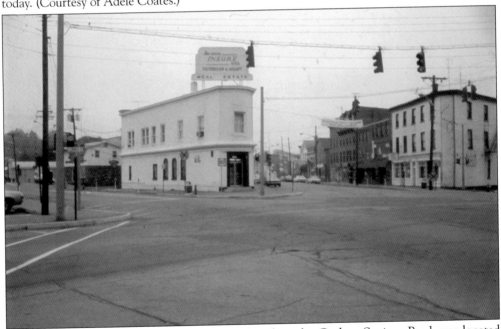

Harriman Square is pictured here in the 1970s, when the Goshen Savings Bank was located downstairs at One Harriman Square and the Dickerson and Meany Insurance Agency was located upstairs. The large, neon Dickerson and Meany sign on top of the building was a landmark for many years, until both the bank and the insurance agency moved across the street into the new bank building on South Church Street. (Courtesy of the Orange County Historian's Office Collection.)

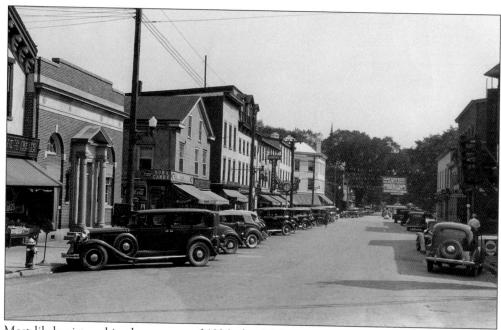

Most likely pictured in the summer of 1936, the A&P is to the immediate left and the Grand Union farther along West Main Street. A barbershop is in the current Howell's Café building. The large banner hanging over the square is advertising auto races at Good Time Park. (Courtesy of the Goshen Public Library and Historical Society.)

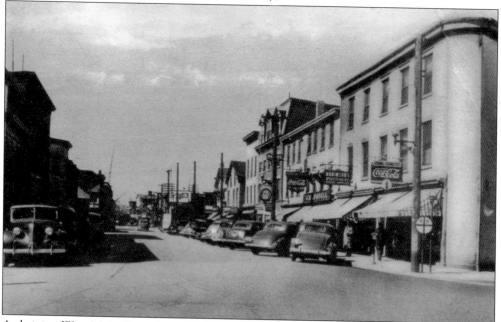

A thriving West Main Street business district can be seen in this late 1930s photograph. Note the hanging signs of Robinson's Stationery store, Lobdell's Ice Cream Parlor, and the Pantre restaurant that later moved across the street and became known as Howell's Luncheonette. The grocery store on the corner later became the site of a barbershop. (Courtesy of the Goshen Public Library and Historical Society.)

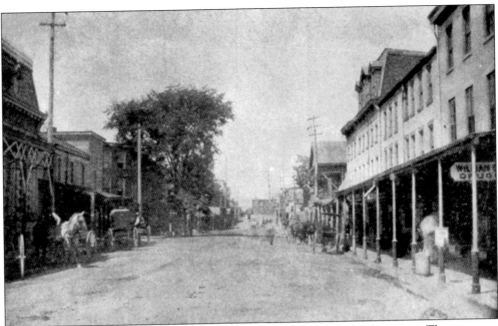

This c. 1892 photograph shows West Main Street, looking west from the square. There are two wooden buildings on the site of the current Howell's Café brick building. Note the numerous horse and buggies, evidence of a thriving commercial center after the railroad came to Goshen in 1841. (Courtesy of the Goshen Public Library and Historical Society.)

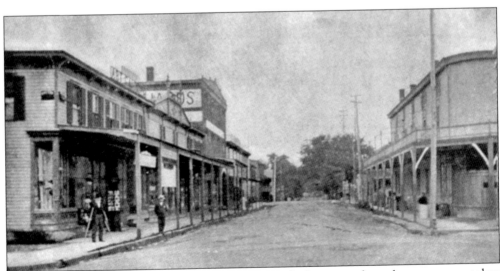

This unique early photograph of Greenwich Avenue, looking west from the square, was taken about 1892. The buildings on the immediate left were razed to make room for the current bank building on the square. The building to the right is One Harriman Square, which houses law offices today. Note the bearded man on crutches posing for the camera on the left. (Courtesy of the Goshen Public Library and Historical Society.)

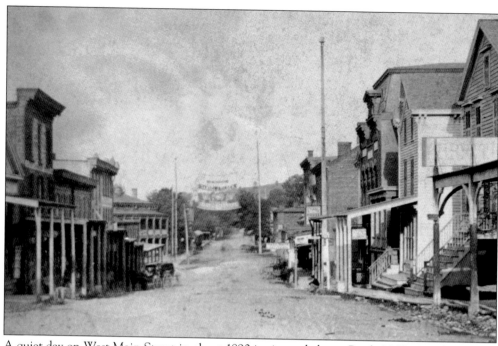

A quiet day on West Main Street in about 1890 is pictured above. Purdy Hall is on the right in the building that is currently Catherine's Restaurant. Purdy Hall was used as a music hall and also as a nickelodeon. The very large banner hanging across the street is suspended from two very high poles, possibly advertising a political candidate or party. (Courtesy of the Village of Goshen's Historian's Collection.)

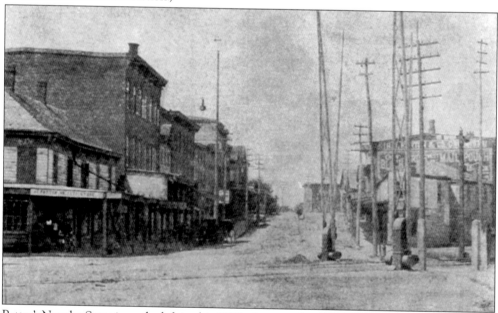

Potter's Novelty Store is on the left in this 1890s photograph of West Main Street. Potter's was an early version of what would later be known as a "five and dime store." Potter's later moved into the building next door that is currently a vacant lot. Addison Earl Potter was born in Wawarsing. He lived on Orange Avenue. (Courtesy of the Goshen Public Library and Historical Society.)

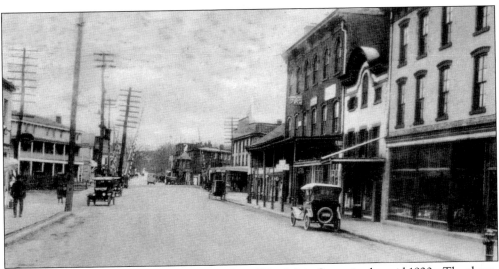

The dawn of the automobile age is evident along West Main Street in the mid-1920s. The three-story brick building to the right was the site of Potter's Novelty Store, and in the 20th century, it was a butcher shop, the Tavern, and Jack Benny's bar, before it was demolished in the 1980s. The Occidental Hotel can be seen to the left in the distance. (Author's collection.)

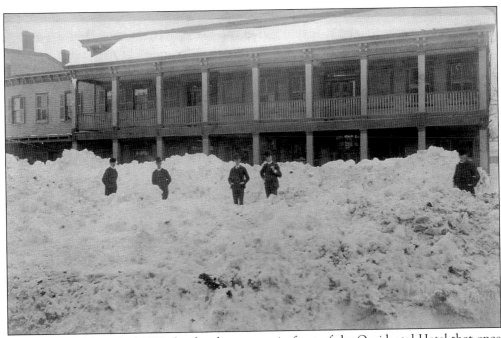

Following the blizzard of 1888, five local men pose in front of the Occidental Hotel that once occupied the site next to the current post office on Grand Street. The hotel began as the Pavilion Hotel in 1841, when the railroad came to Goshen. It was built by George D. Wickham. (Courtesy of the Goshen Public Library and Historical Society.)

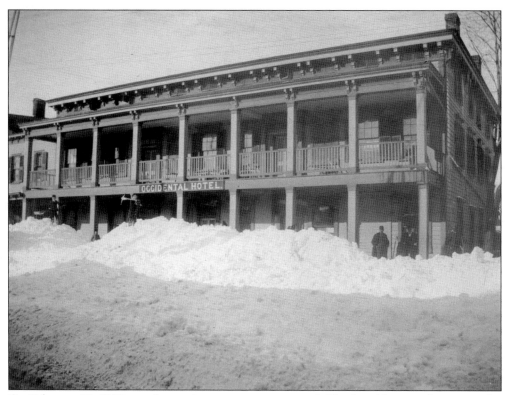

On February 14, 1899, another major snowstorm occurred. The hotel became known as the Occidental Hotel in 1872, when Col. E.R. Abbott became the owner. In this photograph, the hotel had square columns, which were later replaced by round columns. (Courtesy of the Village of Goshen's Historian's Collection.)

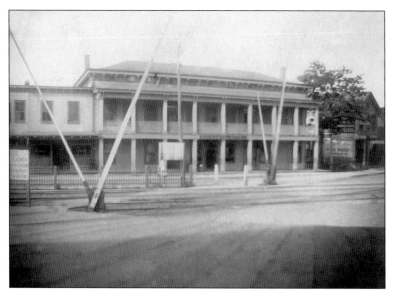

This photograph shows the Occidental Hotel. The hotel was a popular place for those traveling on the trains that stopped at the station across the street. The hotel also had a barn behind it where horses could be stabled. (Courtesy of the Goshen Public Library and Historical Society.)

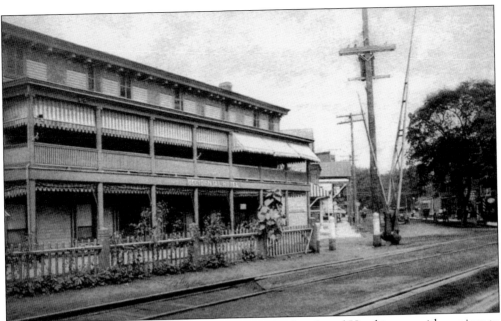

Pictured here, probably at the height of its success, the Occidental Hotel is seen with awnings to help keep the hotel cool on hot summer days. By the time this photograph was taken in the early 1920s, round columns replaced square ones, and larger windows were added on the third floor. It was a time when both automobiles and horse and buggies could still be seen on West Main Street. (Courtesy of the Goshen Public Library and Historical Society.)

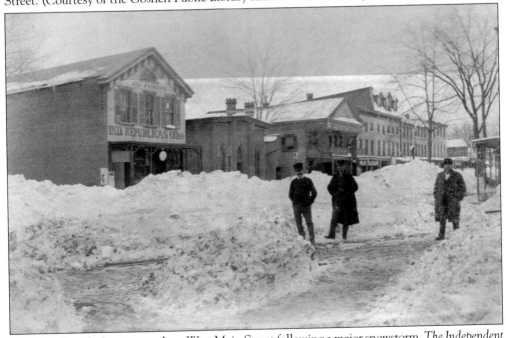

Three unidentified men pose along West Main Street following a major snowstorm. *The Independent Republican* offices were upstairs in the building that is now Baxter's Pharmacy. The Bank of Orange County building can be seen next door before it was renovated and enlarged. (Courtesy of the Goshen Public Library and Historical Society.)

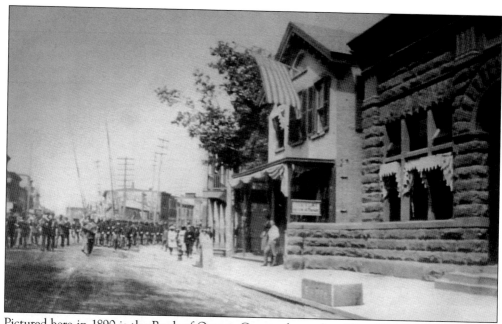

Pictured here in 1890 is the Bank of Orange County, located on West Main Street. The bank was chartered in 1812 and got its start in the current village hall, Maplewood. It moved to the West Main Street location in 1852. The building was enlarged to the structure as it is today. The current Baxter's Pharmacy building is to the left. That building was the site of the Hulse Jewelry Store with Jamieson's Restaurant in the basement. A band can be seen leading a military unit past the Occidental Hotel. (Courtesy of the Village of Goshen's Historian's Collection.)

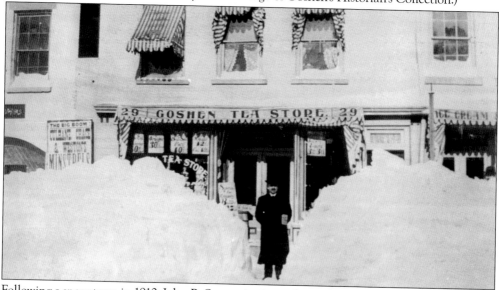

Following a snowstorm in 1910, John B. Swezey is pictured outside of the Goshen Tea Store (now Linda's Office Supplies) on West Main Street. Swezey was supervisor of Goshen from 1920 to 1923. He was president (mayor) of the village for three years from 1919 to 1921, and from 1920 to 1924 he was chairman of the County Board of Supervisors. A descendent of Moses Swezey, his son was Marshall Swezey, and he was the grandfather of Mary Gray Swezey Griffith and Lawrence Swezey. (Courtesy of the Village of Goshen's Historian's Collection.)

Previously known as Strong's Pharmacy on West Main Street, this business is now known as Baxter's Pharmacy. The Strong family had a pharmacy on West Main Street for 28 years before moving to this site in 1952. The building was also the site of the Atlantic and Pacific (A&P) grocery store. (Author's collection.)

This is the interior of Strong's Pharmacy. The soda fountain on the left was a popular attraction, removed when the Strongs sold the business. (Courtesy of the Village of Goshen's Historian's Collection.)

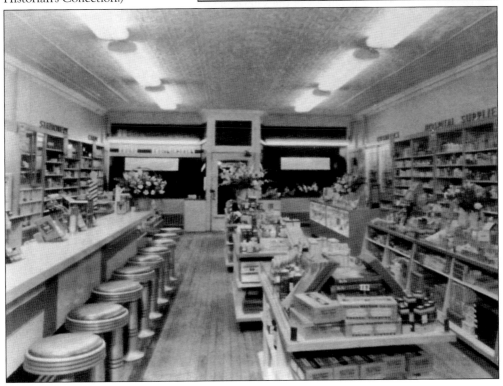

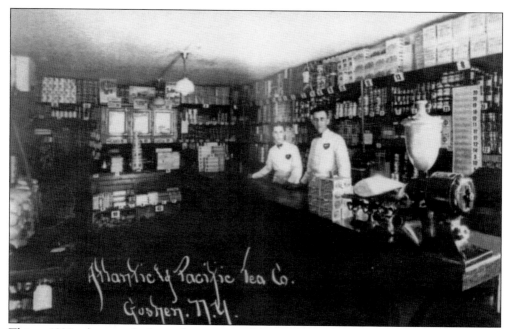

This c. 1920s photograph shows the interior of the A&P in what is now the Baxter Pharmacy building. On the left is C. Leslie Purcell, born in 1903. The gentleman on the right is reported to be Greg Williamson. (Courtesy of Ron Purcell.)

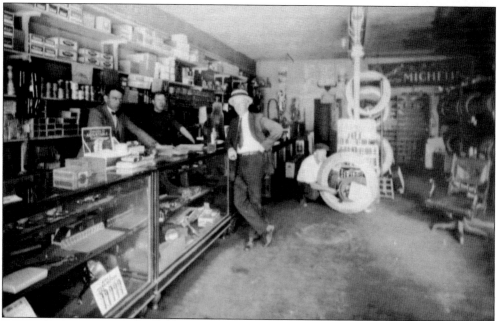

Raymond "Ike" Suresky established his car dealership in 1916 at 160–164 West Main Street, today the site of the Kennett School of Gymnastics. In 1934, Suresky moved to a new garage at 224 West Main Street. His son Harold E. Suresky entered the business in 1947. His wife, Helen, entered the business in the 1970s. In 1982, their son Joseph entered the business. In 1986, the current location of the dealership on 17A and Hatfield Lane was acquired. Raymond Suresky is pictured on the left. (Courtesy of Joseph Suresky.)

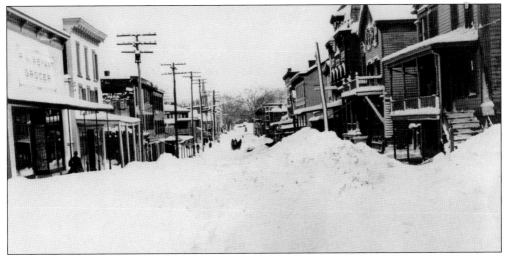

This is a photograph of West Main Street facing the square. Wyant's grocery store was in the building on the left. This building and the one next to it are on the site of the current Kennett School of Gymnastics parking lot. Before Wyant began running his grocery store the site was also a store owned by C.W. Reevs and Son, then Reevs and Kelsey, then purchased by the Fancher Brothers. The building was sold in 1941 to James Anderson, who ran a building supply business. (Courtesy of the Village of Goshen's Historian's Collection.)

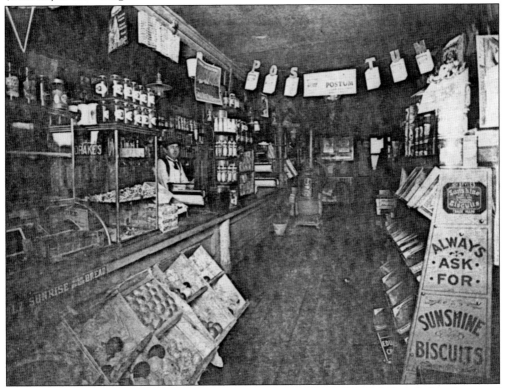

This is the interior of Harry Scott's Grocery store, now Linda's Office Supplies. Before the age of the supermarket, the customer would tell the store clerk what they wanted and the clerk would get the groceries for the customer. (Courtesy of the Village of Goshen's Historian's Collection.)

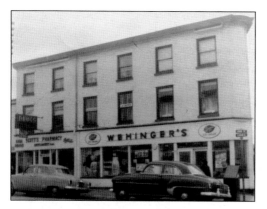

Originally on Walker Street (John Street), Wehinger's was a grocery store that moved into the old Samuel's Clothing store building, now High Wither's Wine and Spirits store, on West Main Street. Samuel's Clothing store was founded by Philip Samuels in 1865 in the building that was on the site of the current vacant lot on West Main Street. He was in that building for 9 years before moving into the Wehinger's building. Zigismund "Zig" Samuels, his son, ran the clothing business until January 3, 1941. (Courtesy of the Village of Goshen Historian's Collection.)

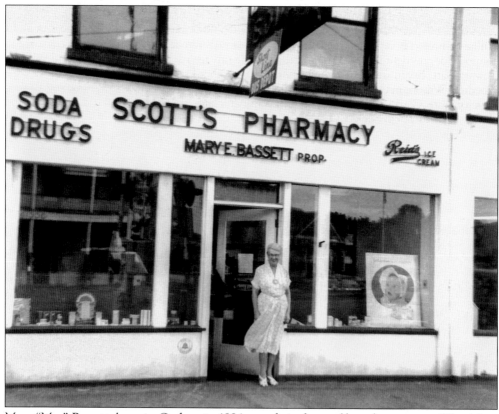

Mary "Mae" Bassett, born in Goshen in 1884, stands in front of her pharmacy on West Main Street. The pharmacy was owned by Philip Powers, who employed Charles Scott, Mae's uncle. Scott worked for Philip Powers for 30 years. In 1911, Powers died and his widow sold the business to Scott, who died soon after. The business was then left to Bassett, who employed Grover Sandford as a pharmacist. On January 31, 1935, Bassett graduated from the New York University School of Pharmacy and became a licensed pharmacist. She retired on January 13, 1955. (Courtesy of the Village of Goshen Historian's Collection.)

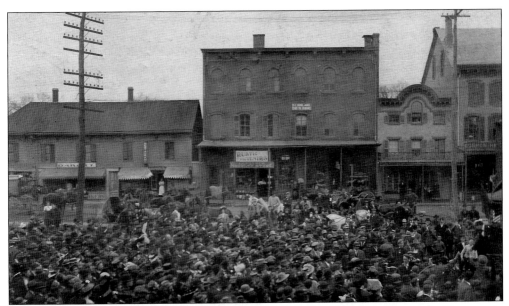

William Jennings Bryan is seen campaigning at the Erie Railroad Station. He was the Democratic nominee for president in 1896, 1900, and 1908. He ran against William McKinley and William Howard Taft. Bryan was also a congressman from Nebraska and secretary of state under Pres. Woodrow Wilson. In the background, from left to right, are a bakery, Clark's Restaurant, Potter's Novelty Store, Clark's Meat Market, and the Goshen Hardware. (Courtesy of the Goshen Public Library and Historical Society.)

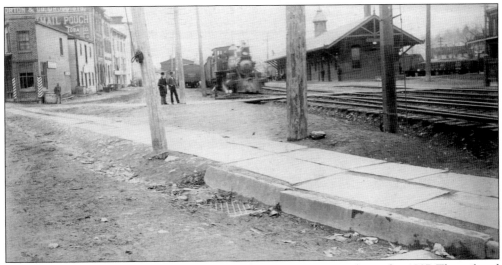

The Erie Railroad Station, today the Goshen Police Station, appears here after 1887. The railroad first came to Goshen in 1841. (Courtesy of the Goshen Public Library and Historical Society.)

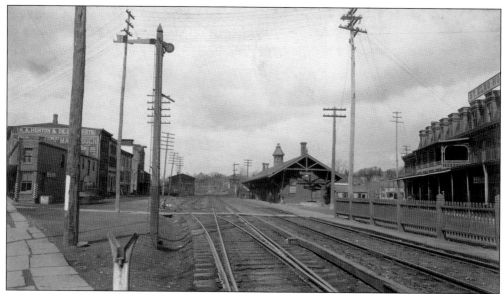

The brick station, built in 1867, was the second station on the site, replacing an earlier wooden structure. The St. Elmo Hotel to the right was built in 1887 and is on the site of the current post office. (Courtesy of the Goshen Public Library and Historical Society.)

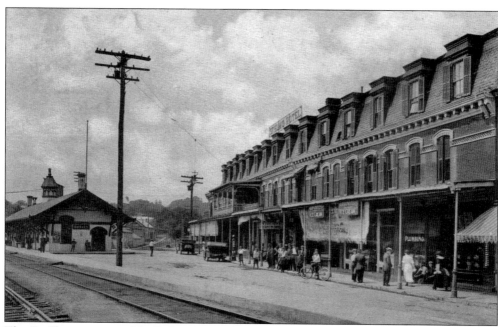

The St. Elmo was owned by Robert B. Hock, who was also the village president (mayor). The hotel opened in 1887 and was destroyed by a fire in 1920. It contained a full-service barbershop, restaurant, and 52 rooms, occupied mainly by travelers who stopped at the railroad station across the street. (Courtesy of the Goshen Public Library and Historical Society.)

This is a photograph of the St. Elmo Hotel's barbershop and gives an idea of the service offered at the hotel. The back wall is filled with shaving mugs. Each customer had their own individual mug that was stored in its own cubby hole. John Hansen Sr. is remembered as the St. Elmo barber. After the St. Elmo fire in 1920, he did business in the barbershop in Finan's Hotel on Greenwich Avenue. None of the barbers in the photograph have been identified. (Author's collection.)

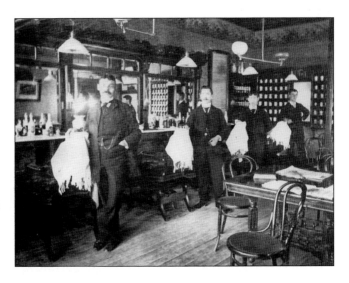

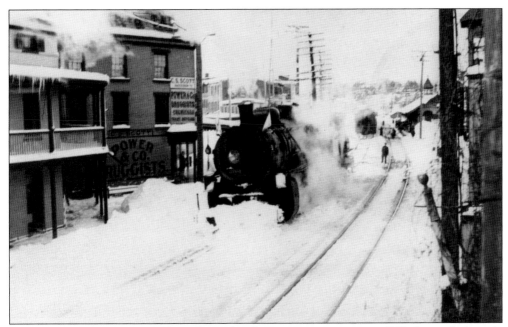

A train engine plows the snow from the tracks after a major snowstorm in 1899. A crowd of people can be seen gathered at the station in the distance. To the left, the Power & Co. Druggists, run by C.S. Scott, was located in the building that eventually was owned by Mae Bassett, whose mother was a member of the Scott family. (Courtesy of the Goshen Public Library and Historical Society.)

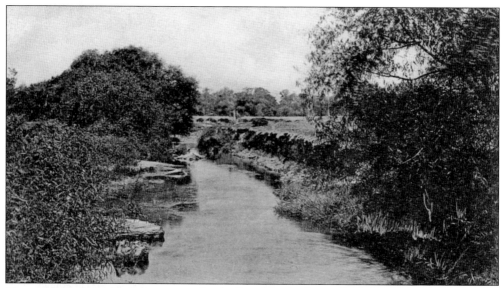

Pictured here is Goshen's famous creek, the Rio Grande. It serves to drain the eastern portion of the village and flows west. According to local folklore, the creek got its name from soldiers returning from the Mexican-American War in 1848, where they saw the Rio Grande, the great river between the United States and Mexico. (Author's collection.)

Located on Grand Street, a portion of this structure that once served as a trolley station still exists. At one time, it also housed a sign-painting business, which continued into the 1990s when Al Schmiderer, and later Lester Carroll, operated their sign-painting businesses here. The trolley ran from Grand Street to Middletown from 1894 to 1924 to mainly service Midway Park, an amusement park along the Wallkill River. The trolley service was suspended because of the increase in train service to Middletown and the closing of Midway Park. (Courtesy of the Goshen Public Library and Historical Society.)

Located in what was Purdy Hall, the Trot Inn was an Italian restaurant owned and operated by the Vitalie brothers: Leo, Frank, and Tony. It later became Brother Ed's, owned by Ed McBride, and then La Monica's Restaurant. Today, it is Catherine's Restaurant, owned by Stephen Serkes. (Courtesy of the Goshen Public Library and Historical Society.)

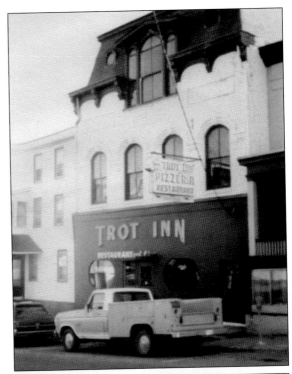

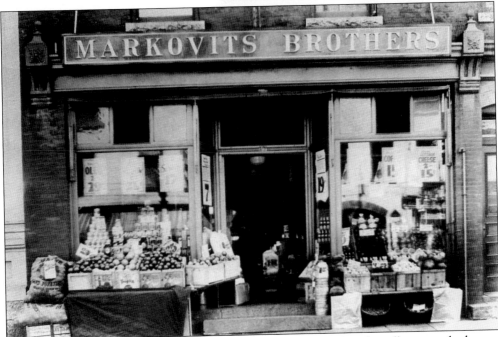

Today, as Goshen lacks a grocery store, it is interesting to note that the village once had many small grocery stores. The one pictured here is the Markovits Brothers grocery store, located in what is now the dining area of Howell's Café. Joseph and James Markovits also had a store in Middletown. The Goshen store was managed by Lawrence S. Taylor for a time. (Courtesy of the Goshen Public Library and Historical Society.)

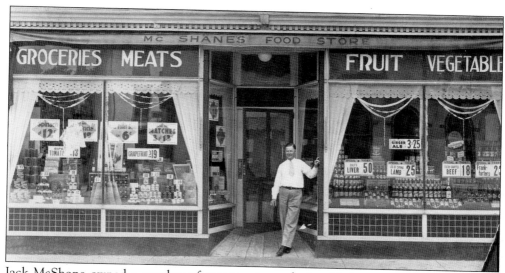

Jack McShane owned a number of grocery stores during his long career in the village. Here he is pictured at one of his larger stores. (Courtesy of the Goshen Public Library and Historical Society.)

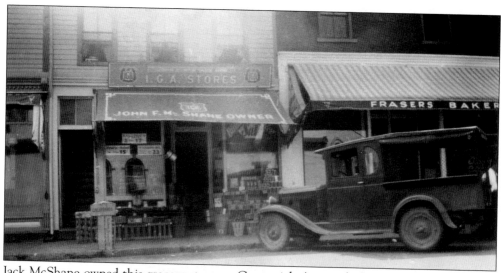

Jack McShane owned this grocery store on Greenwich Avenue before moving to a building around the corner on South Church Street. Both buildings were torn down to make room for the bank on the square. This store was an IGA at the time of the photograph. Next door was Fraser's Bakery. The building later contained the offices of the *Independent Republican*. (Courtesy of Tom Mackey.)

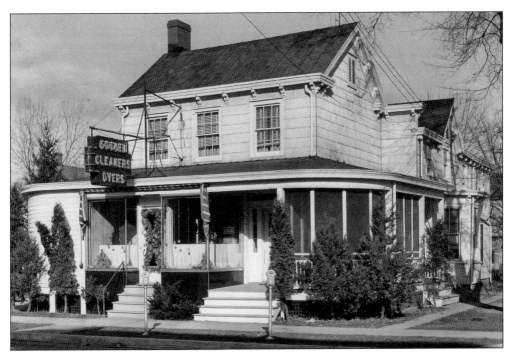

Once owned by Mr. and Mrs. George Wilkes, this house on North Church Street became Bally Brother's Cleaners in 1937. Started by John and Eli Bally, the business was taken over by Raymond and Ron Bally in 1946. It later moved to a building around the corner on St. John's Street that is now a gym. This building alternately housed a florist, gift shop, and a bakery. Antoinette "Toni" Degoede ran a bakery on this site after moving from her West Main Street location. (Courtesy of Ray Bally.)

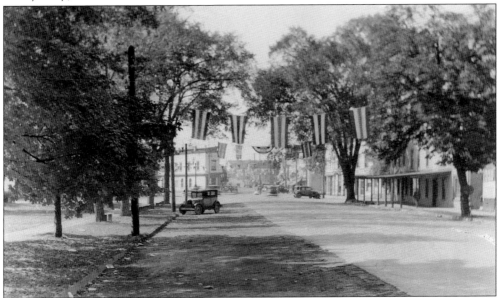

Main Street seems rather peaceful in this 1920s photograph. As the street is decorated with bunting, it was most likely for a fire parade that was about to occur or had already happened. (Author's collection.)

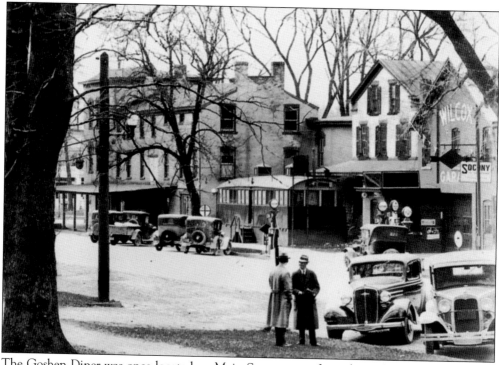

The Goshen Diner was once located on Main Street across from the park. Today, the site is a parking lot. The diner was built in Elizabeth, New Jersey, by the Jerry O'Mahony Diner Company in 1924. It was originally located in Hudson, New York. After about a year there, it was brought to Goshen by Edward and John Gaynor. When attempting to remove the diner from the site in 1959, the wooden wheels became bogged down and broke off. The diner was dismantled on the site and replaced by a "modern" diner that became known as Cy's Diner. (Courtesy of the Goshen Public Library and Historical Society.)

This was the home of Luella Morris Van Leuvan on Greenwich Avenue, who deeded her home to the Goshen Hospital as specified in her will in 1915. After renovations and an addition, the house served as a hospital until 1967, when Arden Hill Hospital was built. In recent times, the building has commonly been known as the Seven Columns. (Author's collection.)

The Van Vliet building was located on the corner of West Main Street and Webster Avenue. This c. 1890 photograph shows it before the flat-iron-shaped extension was added to the left of the building. William Van Vliet was a manufacturer and dealer in furniture, bedding, window shades, door mats, and rugs. He began operating his store in 1864. Van Vliet was also president of the board of education and resided in the family house on Webster Avenue. (Courtesy of the Goshen Public Library and Historical Society.)

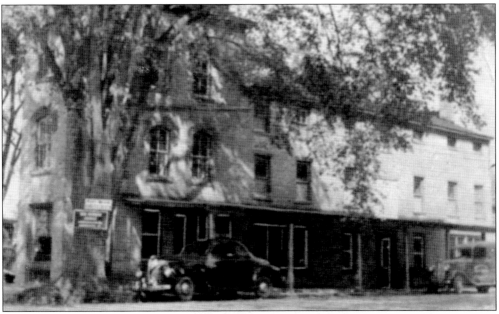

This c. 1930s photograph of the Van Vliet building shows the flat-iron addition on the left. The site, in later years, housed the offices of the *Newburgh Evening News* and Piggott's vegetable store. John J. Van Vliet was born in 1871 and took over the family business. He was married to Adelaide Grier and lived in the Webster Avenue family home until his death in 1952. (Courtesy of the Village of Goshen Historian's Collection.)

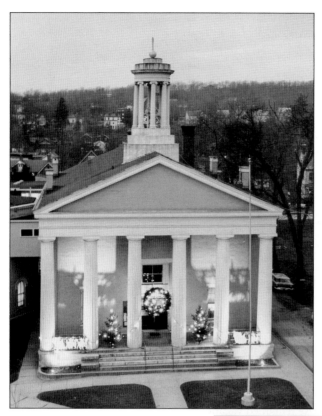

The 1841 Orange County Court House on Main Street is decorated for Christmas in this 1950s photograph taken from the old Orange County Building across the street. The courthouse was designed by Thornton Macness Niven, who was born in 1806 and died in 1875. (Courtesy of the Village of Goshen Historian's Collection.)

This scene of the 1841 Orange County Court House shows it decorated for the holidays following a substantial snowfall. (Courtesy of the Village of Goshen Historian's Collection.)

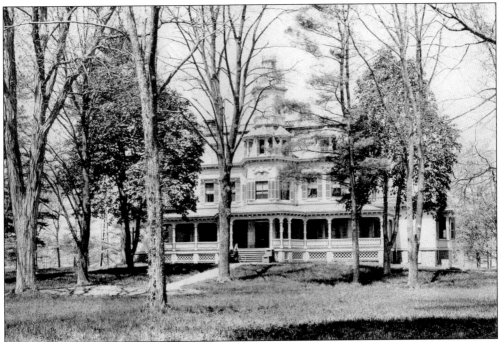

The Interpines once occupied the site of the Orange County Government Center on Main Street. It was built by George D. Wickham in 1816. It was later bought by Robert H. Berdell, who was president of the Erie Railroad. Berdell hired an architect who designed and built this Victorian. He left Goshen in 1876, and the house remained vacant for 18 years. It was then bought by Dr. Fredrick W. Seward Sr., who opened a sanitarium on the site. In 1964, the house and adjacent buildings were demolished to make way for the government center. (Courtesy of the Goshen Public Library and Historical Society.)

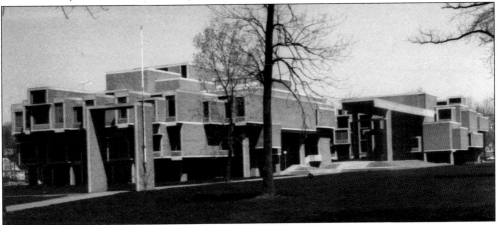

Designed in 1963 by Paul Rudolph and built in 1967, the Orange County Government Center replaced the Interpines and a couple of large houses on the corner of Main and Erie Streets. Rudolph was dean of the Yale School of Architecture and designed a number of buildings in what is known as the Brutalist style. Rudolph was born in Elkton, Kentucky, in 1918 and died in New York City in 1997. Controversial since the day it opened, the building recently sustained water damage from a hurricane; its future is uncertain. (Courtesy of the Village of Goshen Historian's Collection.)

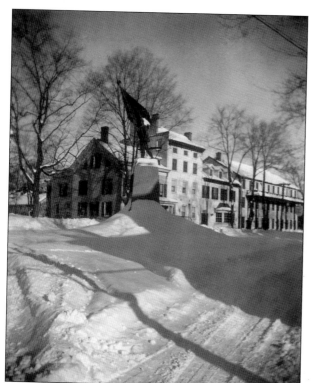

After a substantial snowfall, the Orange Blossoms monument stands at the intersection of Main Street and Park Place. The monument was dedicated in 1907 to the veterans of the 124th New York Volunteer Infantry Regiment, known as the Orange Blossoms. In the distance, the Orange Inn is now the site of the Limoncello restaurant. (Courtesy of the Village of Goshen Historian's Collection.)

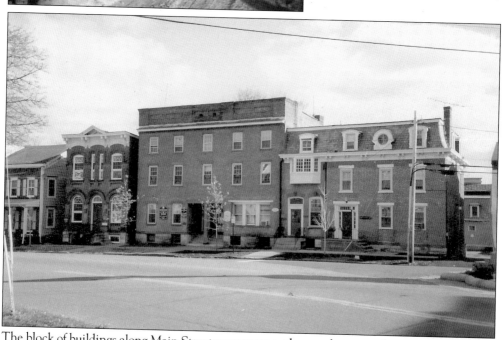

The block of buildings along Main Street encompasses the area known as Lawyers' Row. After a disastrous fire destroyed the block in 1843, brick buildings were built. At one time, this area was the commercial center of the village. When the railroad came to Goshen in 1841, the commercial area moved west nearer to the railroad tracks and Erie Railroad Station, now the site of the village of Goshen Police Department. (Author's collection.)

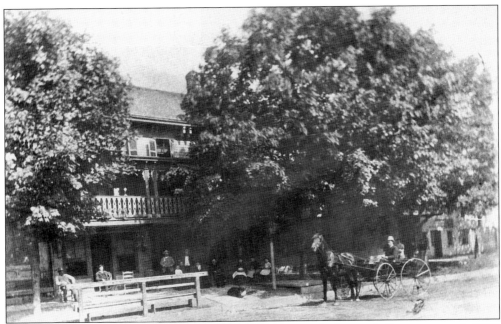

This is a photograph of the Orange Inn on Main Street, now the Limonchello restaurant. In 1879, Peter Goode operated the inn that was owned by the Coates brothers, George and John. From left to right are porter Riley Mines, unidentified, Peter Goode, Peter Goode's son George C. Goode, Mrs. Peter Goode, attorney W.O. Wyker, Mr. and Mrs. Bishop from Jersey City, their daughter Mae, Peter Goode's daughter Mary Goode, and Miss Flo. The driver of the wagon is John Minchin. The horse is named Tariff. (Courtesy of the Goshen Public Library and Historical Society.)

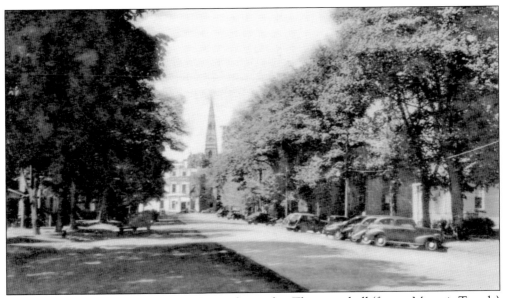

Main Street in the 1940s appears much as it does today. The music hall (former Masonic Temple) is on the right. The street was paved concrete in the center, but the side of the road remained dirt. (Courtesy of the Goshen Public Library and Historical Society.)

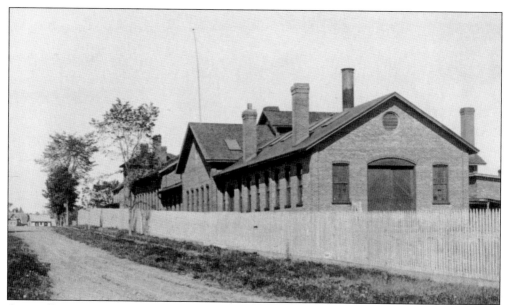

Originally opened as a gas equipment company in 1880 by J.H. Van Steenburgh, the company went bankrupt after the village started using electricity for street lighting. Jay Newbury took over the company in 1896, and the pipefitting company became known as the Newbury Foundry. His son, George C. Newbury, took over the management of the company in 1929 when his father died. He sold the company in 1952. Village residents could set their clocks to the foundry whistle that blew every day at 7:00 a.m., noon, and 3:30 p.m. (Author's collection.)

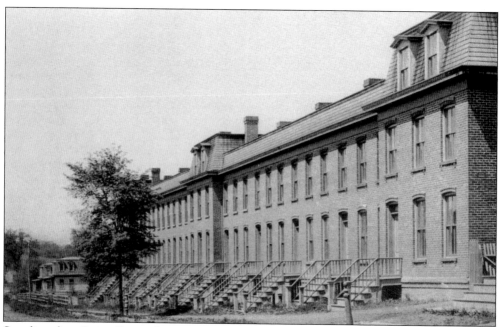

Standing along Spring Street, these apartments were occupied by foundry workers. The apartments, located across the street from the foundry, were built around 1880. (Author's collection.)

Three

FARMS, HOUSES, AND ROADS

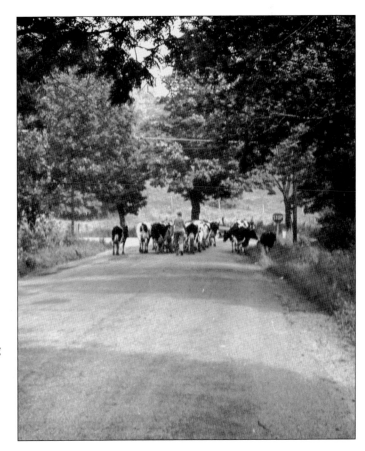

This was once a common site throughout the town of Goshen. Farmer Floyd Makuen Jr. is seen walking his cows from the pasture on Houston Road to the barn across the street on the Florida Road/Route 17A. (Courtesy of Floyd and Teresa Makuen.)

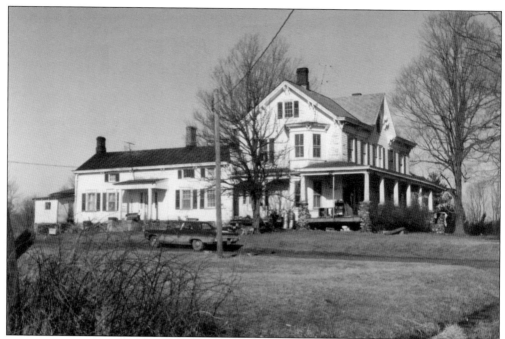

Once located on 6 1/2 Station Road, this farm was known as the Holbert farm from the 1850s into the early 1900s. The older, Greek Revival section can be seen to the left rear with the later and larger Victorian section in the front. The house was destroyed by fire in the late 1970s. The new Orange County Correctional Facility was built in the field behind this house.

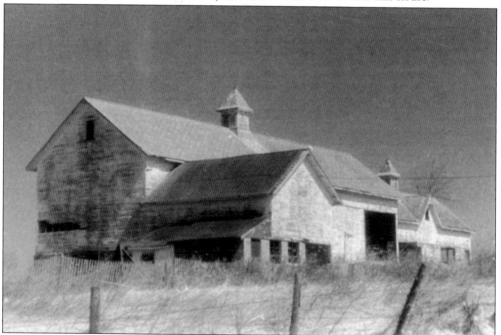

This large barn was on the Holbert farm on 6 1/2 Station Road. The size of the barn, which survived some years after the house, is indicative of the large farming operation. (Courtesy of Patty Garnett.)

This house was part of the Wells homestead, located on 6 1/2 Station Road. The Wells family settled on this farm in 1735. Joshua Wells, who was born in 1779 and died in 1867, built this house. Orange County acquired the property, and the house was demolished in the early 2000s. To the rear of the property is the Orange County Emergency Service Center.

This photograph shows 6 1/2 Station Road looking west, when it was a dirt road. The house on the right, still standing today, was the home of the Wood family in the 1800s. It later passed to the Smith family, and in the 1970s, it was the home of Louis and Marion Smith Shesa. (Author's collection.)

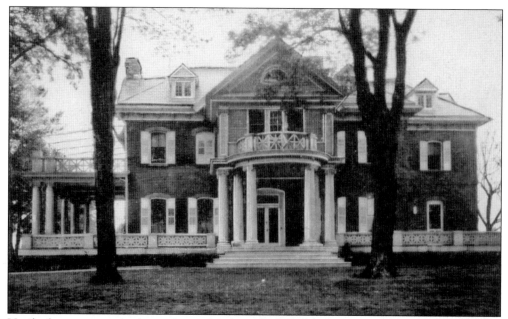

Until a few years ago, this house, located at the end of Fletcher Street, was known as the Lakeville Inn, which was run for many years by the Gabella family. The house is pictured here before the front porch roof was added. In the 1800s, it was an Everett family home, and in early 1900s, the Holbert family lived here. Later in the century, it was owned by the Nortons and Cornelius McCardell. The house still stands and is now owned by the Catholic Diocese of New York. (Courtesy of the Goshen Public Library and Historical Society.)

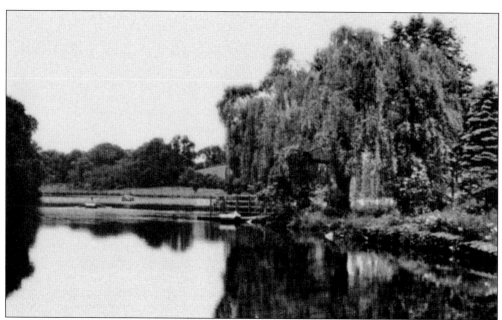

This is the pond behind what was once the Lakeville Inn. (Author's collection.)

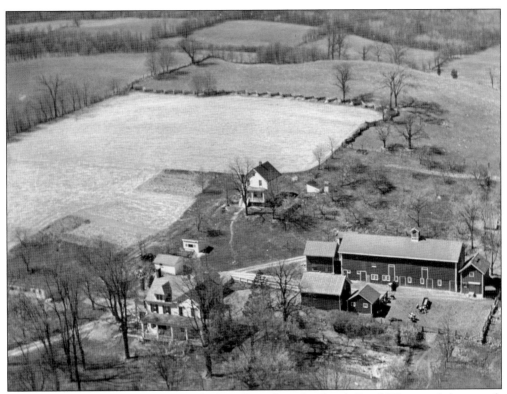

The Makuen farm is situated just outside the village along the Florida Road. This aerial photograph of the farm faces west. As early as the 1850s, the farm belonged to J.W.A. Brewster. By the late 1800s, it had passed to the Staats family. It has now been in the Makuen family for many years. (Courtesy of Floyd and Teresa Makuen.)

This is another aerial photograph of the Makuen farm facing east. The one-mile racetrack, Good Time Park, can be seen in the distance. The track was the site of the running of the Hambletonian Stakes, the Kentucky Derby of harness racing. The land across the street is now the location of Eastgate Corporate Park. (Courtesy of Floyd and Teresa Makuen.)

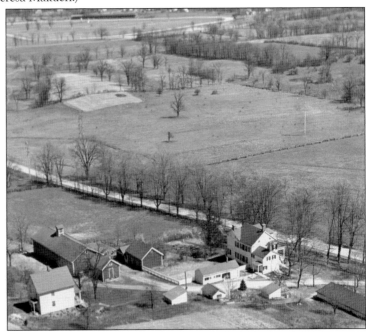

The Florida Road/Route 17A is seen here when it was a tree-lined dirt road. The photograph is believed to have been taken in the area of Houston Road. (Courtesy of the Goshen Public Library and Historical Society.)

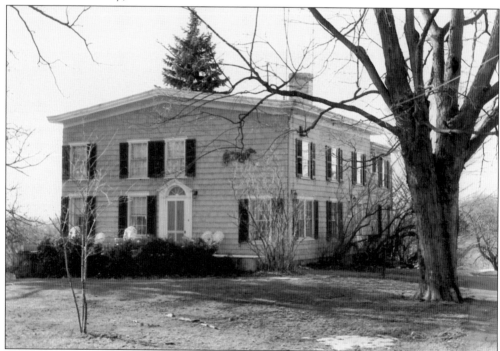

This house was in the Smith family into the late 1800s. It was built around 1850 along Route 17A on the Florida Road. In the early 1900s, owner Horace King called it Shadeland Farm and raised horses there. From the 1960s until around 2000, the house belonged to the Dickerson family.

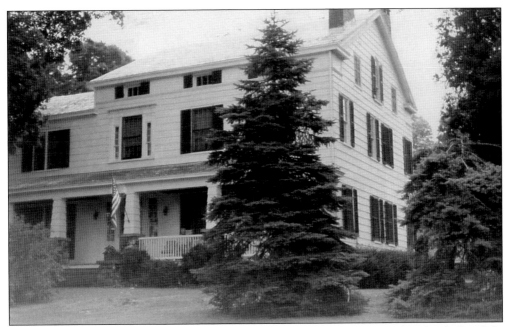

The c. 1786 Copper and Van Duzer house is situated along Route 17A on the Florida Road. In 1869, the Houston family came to Goshen and owned the house for decades, well into the 1980s. Around 1900, the farm was called Willow Brook.

This is an aerial photograph of what was once the Howell farm along Route 17A on the road to Florida. The Howell family owned the farm from the 1850s into the 1900s. The farm later served as a commercial dairy for Borden Farms. The extensive creamery and barns no longer exist. The site is located just before the old stone schoolhouse and pond on the road to Florida. (Courtesy of the Goshen Public Library and Historical Society.)

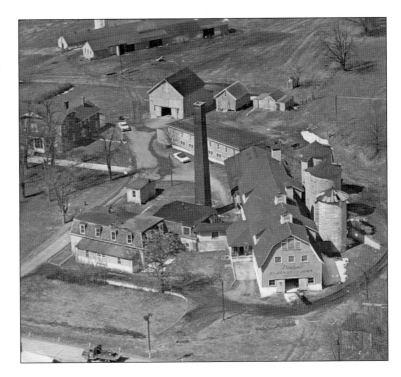

Located well back from Route 17A, the Florida Road, Brookfields Farm is located across the stream. Around 1875, the farm was owned by the McCain family. In the early 1900s, Seneca Jessup operated the farm. It has been in the Myruski family for many years now. (Author's collection.)

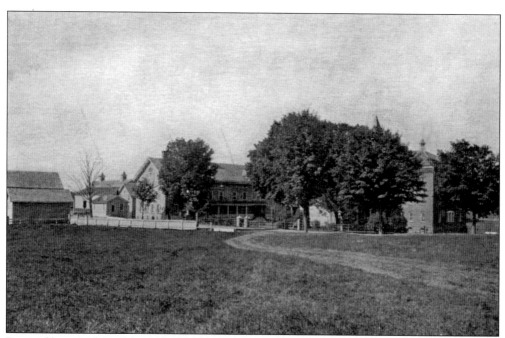

Pictured here is what was once known as Orange County Farm. Today, it is known as Valley View, located off of Pulaski Highway and Quarry Road. The farm was established around 1831 as an economical way of caring for indigent people. The original stone structure was built by John H. Corwin and Samuel Bull of Wallkill. The same stone that was used in building this structure was also used in the construction of St. James's Episcopal Church and the First Presbyterian Church in the village. (Courtesy of the Goshen Public Library and Historical Society.)

Known as Oak Ridge Farm, located on Cheechunk Road, this house and farm, built around 1780, has been in the Strong family since 1816, when Sheriff Ben Strong bought it for his son Walter. Walter married Frances Bradner, great-granddaughter of Goshen's first pastor Rev. John Bradner. It was at that time that the house was enlarged. A carpenter named Gregg lived on the farm for two years carving the interior trim and preparing lumber for the 1816 addition. No two mantels in the house are alike.

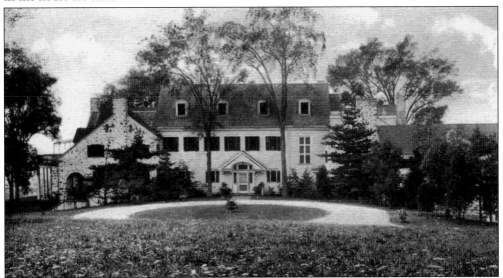

Today commonly known as Broadlea, this house was originally built for the E.G. Tweedy family around 1916. It was purchased by the Sisters of St. Dominic and for years run as a girls boarding academy known as the Academy of Our Lady of the Blessed Sacrament. The school opened in 1927 and closed in 1971. (Author's collection.)

The Old Chester Road once served as the main "highway" from New York City to the Catskills. The road then supplied the village with a steady stream of traffic until Route 17M was built and later Route 17, known as the Quickway. This photograph was taken just past the junction with the road we today call the Duck Farm Road heading toward Chester. (Courtesy of the Goshen Public Library and Historical Society.)

This is a photograph of Old Chester Road, just outside the village limits. Slate Hill Cemetery is on the left. The cemetery contains the graves of many veterans and prominent Goshen residents, including Dr. Benjamin Tusten, Gates McGarrah, Anna Dickinson, US Congressmen Henry Bacon, James Whitney Wilkin, and Samuel Jones Wilkin, as well as Gen. Abraham Vail and Henry Lawrence Burnett, who was special judge advocate for the Lincoln assassination trial. (Author's collection.)

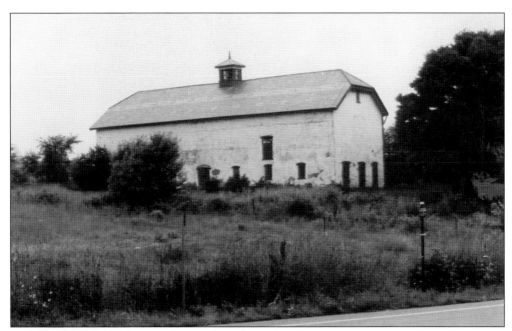

This unusual brick and stucco faced barn was once located along Route 17M on the road to Chester. It also had a detailed slate roof. The farm where the barn was located was in the Seely family from the early 1850s well into the 1900s. The original farmhouse is now the site of the Hacienda restaurant. (Courtesy of the Orange County Historian's Office Collection.)

This is the old iron railroad bridge that once connected Old Chester Road to Route 17M. It was located near the current golf driving range. Once the railroad abandoned the line, the tracks were removed and the Heritage Trail bike path was created. (Courtesy of the Goshen Public Library and Historical Society.)

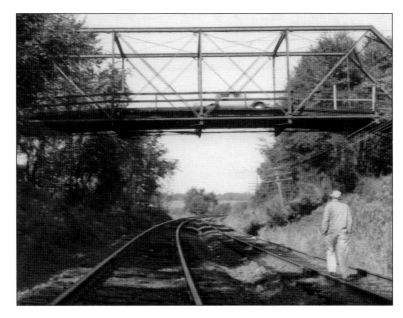

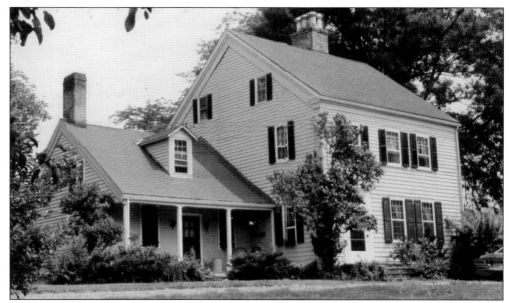

Situated off Ridge and Craigville Roads is this pre-Revolutionary house once belonging to the Rumsey family. Squire Rumsey settled in Goshen around 1723. His son Phineas was born in 1734. The left section of the house was built around 1735. In 1868, the Rumseys sold the farm to Charles Dunning. In the late 1800s and early 1900s, it was owned by the Murray family. Then, in 1915, it passed to Squire Buckley. It has been in the Wallace family since the 1950s.

At one time, this farm was the first house outside of the village on Scotchtown Avenue. It was located next to the current football and baseball fields on Scotchtown Avenue. Built around 1830, it was owned by John Stafford in the mid-1800s. It then was owned by the Cuddeback family until 1917, when Augustus T. Cuddeback sold the farm to Franklin D. Buell, who sold it to Nora and Peter Zabachta, the author's grandparents, around 1930. The house was demolished in the early 2000s. (Author's collection.)

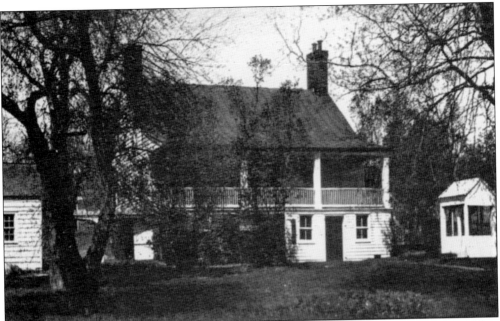

Built around 1760, this house along Route 207, going out of the village, was left to Christopher Springsteen by his father, Abraham, in 1776. According to the will, it was "lately purchased from David Horton." In 1806, Christopher's widow sold the farm to Daniel Seward, another Goshen family member. Seward owned the Eagle House Hotel, which burned in 1843, now the site of the drive-through bank on the square. In 1834, he sold the house to Hudson Duryea, and then in 1864, John Cohalan of Greenville bought the house. (Courtesy of Mildred Parker Seese.)

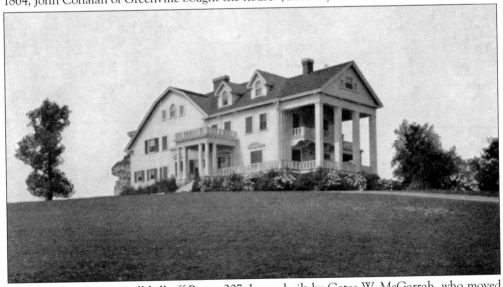

This house sits on a small hill off Route 207. It was built by Gates W. McGarrah, who moved to Goshen from Monroe, where he began his banking career at 18 at the Goshen National Bank. He later became chairman of the Federal Reserve Bank of New York. McGarrah died in 1940. The house later became the home of William Cane, who was responsible for bringing the Hambletonian to Good Time Park. In later years, it was the home of the Geddes and Griffith families. (Author's collection.)

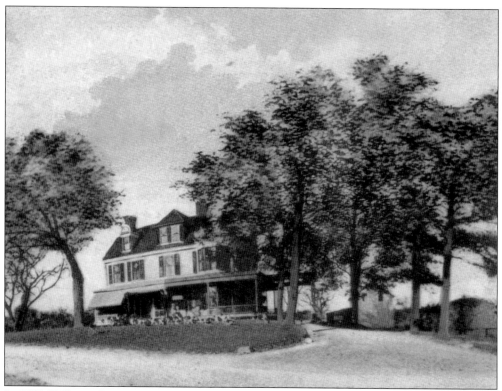

In 1878, William Phineas Richardson came to Goshen, and by 1881, he purchased this house on the Philipsburgh Road. In 1889, he was elected state senator. He called the property Springdale Farm. It had a racetrack where Edward Harriman boarded and raced his horses for a time. The house was used as the clubhouse for the Orange County Hunt Club. In the early 1900s, the farm was owned by the Gregory family, and in more recent years it was known as the Tobias farm. (Courtesy of Richard and Cecile Ayres.)

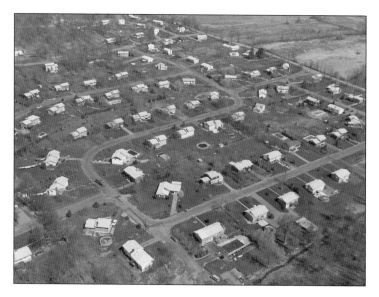

This is Hambletonian Park off Craigville Road, soon after it was completed in the 1960s. Cassel and Sherlock, who built other homes in the village and the town, built theses homes. Craigville Road and the Salesian property can be seen in the upper right. (Courtesy of the Village of Goshen Historian's Collection.)

Four

CATARACTS, DIKEMANS, MINISINKS, AND PARADES

Members of the Minisink Hook and Ladder fire company pose on their truck on Main Street in 1911. Those in the photograph are Arthur Decker, Charles M. Knapp, William K. Dickerson, Frank C. Hock, Edward Farrell, George Gregg, P.A. Rorty, A.O. Snow, Russell Ashman, and Frank Hages. (Courtesy of the Goshen Public Library and Historical Society.)

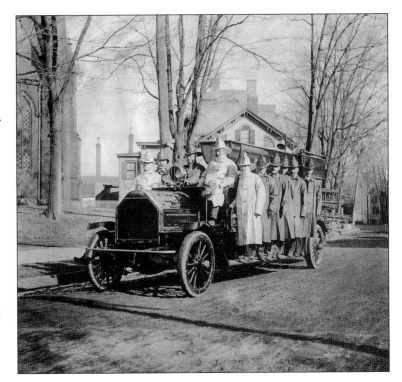

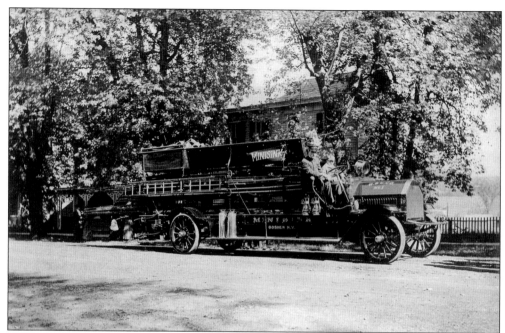

The Minisink truck is seen on a village street in this later photograph. The Minisinks can trace their roots to 1871, when they were known as the Rescue Hook and Ladder Company. They became known as the Minisink Hook and Ladder Company in 1906. (Courtesy of the Goshen Public Library and Historical Society.)

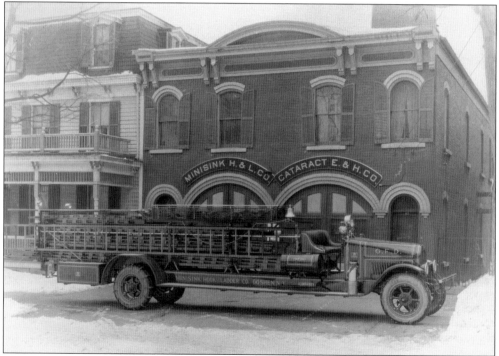

A Minisink Hook and Ladder Co. truck is seen in front of the Minisink and Cataract firehouse on Main Street. (Courtesy of the Goshen Public Library and Historical Society.)

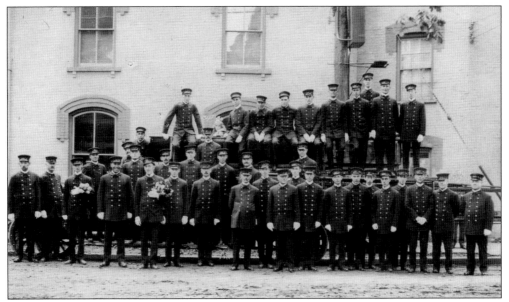

The members of the Minisink Hook and Ladder Company are posing in their parade uniforms sometime during the 1920s. (Courtesy of the Goshen Public Library and Historical Society.)

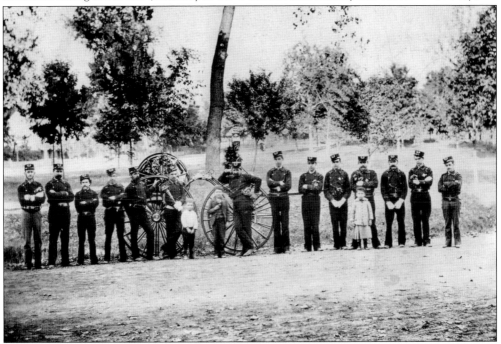

The Dikeman Hose Company poses by the park on May 30, 1877, four years after the organization of the fire company. From left to right are William McNeiece, George Smith, Thomas Farrell Sr., Walter Scott, John T. LaRue, George Landy, Edward Wood (boy), Edward Farrell (boy), William Wood, Elmer McFarland, William O'Neal, E. Wellington White, Lang Murray (boy), James Landy, Floyd Ray, C. Augustus White, and John B. Swezey. In 1874 at Monticello, New York, the Dikemans participated in their first firemen's parade. (Courtesy of the Goshen Public Library and Historical Society.)

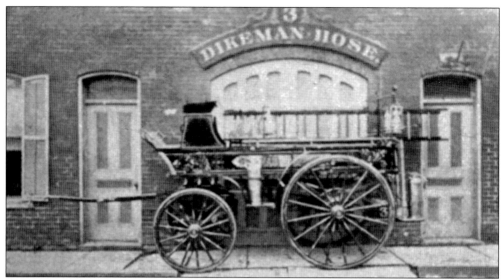

This early Dikeman truck is seen in front of the former Dikeman fire house on New Street. The Dikeman Hose Company was formed in 1873 and moved into the New Street location in 1885. (Courtesy of the Goshen Public Library and Historical Society.)

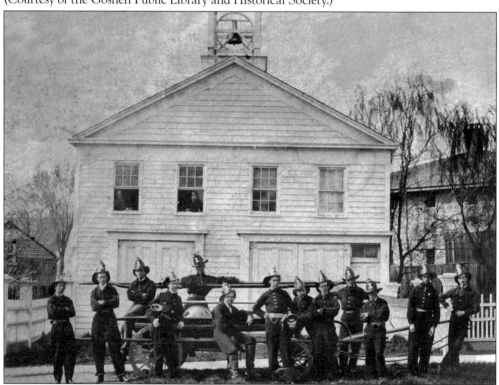

Members of the Cataract Engine and Company are pictured in 1864 in front of the former Main Street firehouse. Some of the members who have been identified are David Osmun, Henry Jackson, H.M. Moor, Mike Simmer, Charles Jackson, Thomas Sayer, Patrick Cody, Nathaniel M. Jay, Edwin Roys, John Smith, and Chief Elliott, fourth from the right. This firehouse was replaced by the brick building visible today. (Courtesy of the Goshen Public Library and Historical Society.)

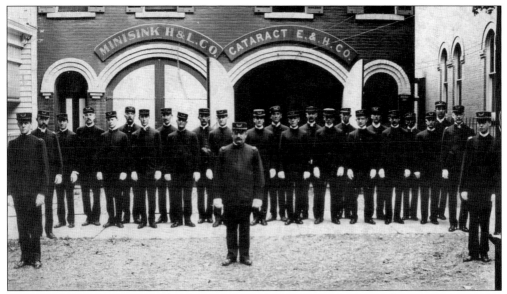

The Cataracts pose in front of the Main Street firehouse sometime during the 1920s. In 1843, the Goshen Fire Engine Company No. 1 was formed and eventually became the Cataract Engine and Hose Company. (Courtesy of the Goshen Public Library and Historical Society.)

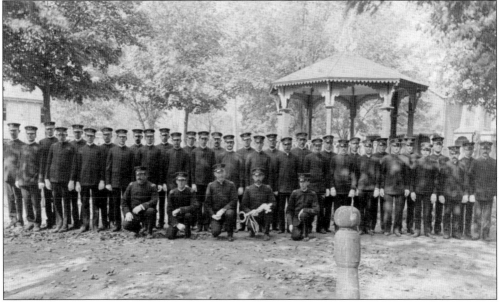

The Cataract Engine and Hose Company poses October 14, 1909, at a fire parade in Walden. From left to right are (first row) Frank C. Hock, captain; Dr. Charles H. Thompson, foreman; Rev. F.S. Haines, chaplain; James Scott Jr., president; and Harry H. Smith, asst. foreman; (standing) Charles Scott, Carlton I. Smith, William McNeiece Jr., Signey Johnson, Arthur Duryea, Harold Parker, Andrew Scott, Robert LaRue, Edward A. Hopkins, Herman Strack, Harry J. Scott, Bert Smith, Dell Sayer, Millard McNeiece, H.S. Chardavoyne, Henry Jonas, Hiram H. Smith, Ivan Gardner, F.W. Chardavoyne, R.D. Botting, ? Sayer, Wellington White, Fred Clark, R.N. Weyant, William Monroe, R. Wilson White, Fred Glass, James Wilcox, John Rutan, P.V.D. Gott, George Stull, and William Vandermark. (Courtesy of the Goshen Public Library and Historical Society.)

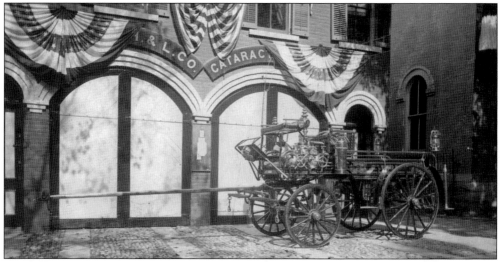

Pictured is the Cataract truck, the Rex, which came to Goshen on July 12, 1904, at a cost of $1,800. It was made by the Rex Fire Extinguisher Company of New York City. Considered advanced technology for its day, it carried 1,000 feet of fire hose and had four brass tanks in which bicarbonate of soda was mixed with liquid acid (probably vinegar). The chemical reaction generated carbon dioxide gas, used to pressurize the water into a hard stream, eliminating the need for hand pumps. (Courtesy of the Goshen Public Library and Historical Society.)

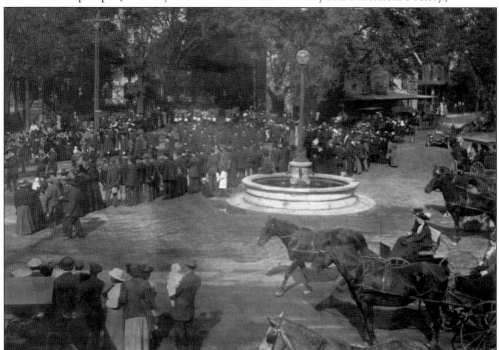

This is a fire parade coming down Webster Avenue to the square at Main Street. The Harriman Memorial Fountain was installed in 1911, so the parade was held sometime after that year. A fire company is marching just in front of the fountain, led by a band with another band just coming down Webster Avenue. Note the two cars on Main Street to the right, surrounded by horse and buggies. (Courtesy of the Goshen Public Library and Historical Society.)

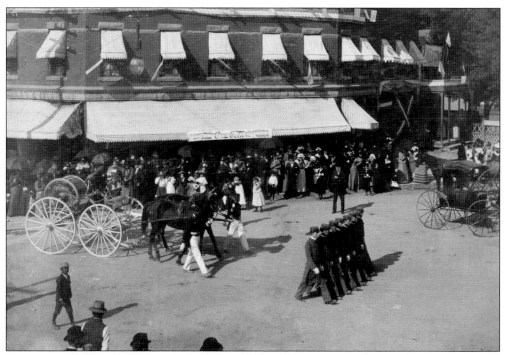

Firemen are seen marching across the square, followed by an early fire apparatus. The Dayton/Seely building is seen in the background before being painted the yellow color it remained for many years. The building was recently stripped of yellow paint. (Courtesy of Tom Mackey.)

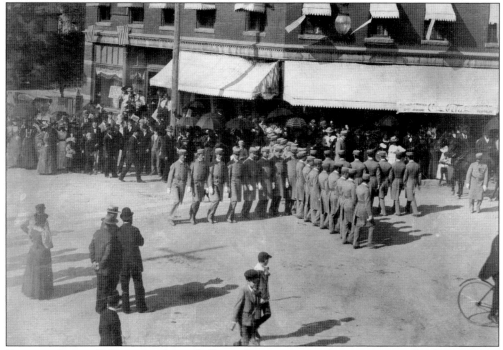

Firemen show off their marching skills in the square in a late-1800s parade. (Courtesy of Tom Mackey.)

Firemen march in front of the 1841 courthouse on Main Street during a late 1800s parade. (Courtesy of Tom Mackey.)

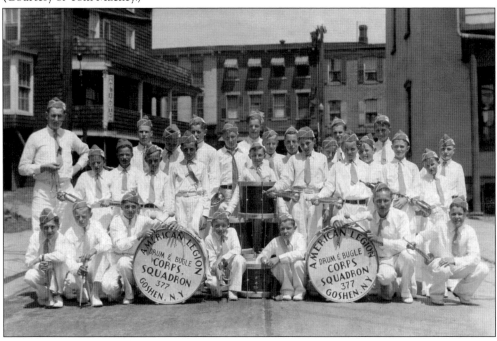

The American Legion Drum & Bugle Corps Squadron is on New Street in 1935 or 1936. Identified are (first row) Johnny Malinowski, Tony Turi, Adam Filipowski, and John Filipowski; (second row) Leonard Filipowski, Pete Kelly, Buddy O'Brien, and Francis "Mickey" McMahon; (third row) Lynn Morse, William McNeece, Ray Golembowski, Dick Morse, Dusty Shaffer, Coats Remer, and Bill McCluskey. West Main Street is in the background with the Arlington Hotel on the left. (Courtesy of Francis "Mickey" McMahon.)

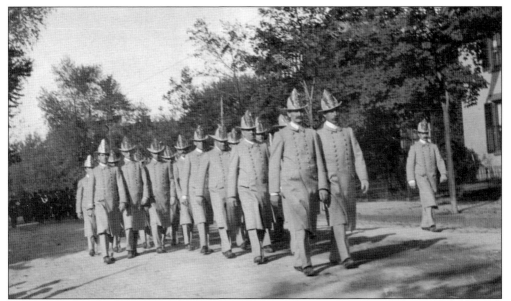

The Dikeman Hose Company, dressed in their parade uniforms, marches in a parade around 1910. William Johnson was the drill master at the time. (Courtesy of the Goshen Public Library and Historical Society.)

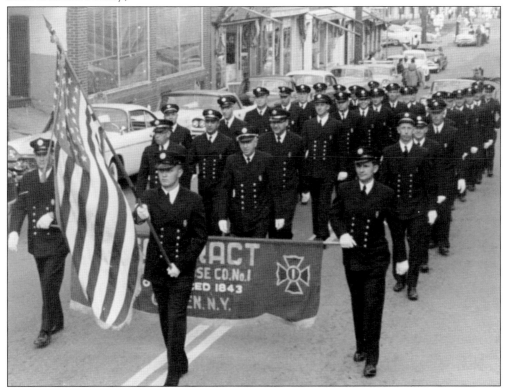

The Cataracts march up West Main Street in a 1960s fire parade. The Goshen Saddle and Harness shop, which opened in January 1952, is visible in the background. The building was once the location of Dikeman's drug store. (Courtesy of Tom Mackey.)

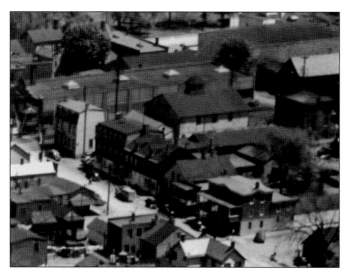

This is an aerial photograph of Finan's Hotel and the adjacent buildings along Greenwich Avenue. Around 4:00 a.m. on December 25, 1962, a fire occurred in the Finan building. The site was later used as Lloyd's gas station. The gas station structure still stands on the site today. A bar, Terry's Beauty Salon, the Triggin brothers' barbershop, a grocery store, and upstairs apartments were totally destroyed in the fire. (Author's collection.)

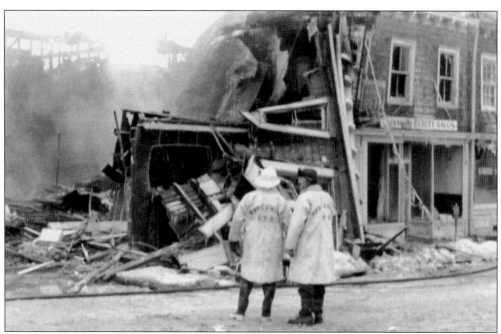

Pictured above are Dikeman assistant chief engineer Alfred Turi Sr. on the left and Cataract assistant chief engineer John E. Connor, the author's father, on the morning of the Finan Hotel fire on Greenwich Avenue. Firemen remained on the scene all Christmas Day. DeWitt "Footsie" Howell was fire chief at the time of the fire. (Author's collection.)

Pictured around 1899, Augustus Lippert appears on New Street after participating in a fire parade as the Dikeman fire company's mascot. West Main Street is in the background. (Courtesy of the Goshen Public Library and Historical Society.)

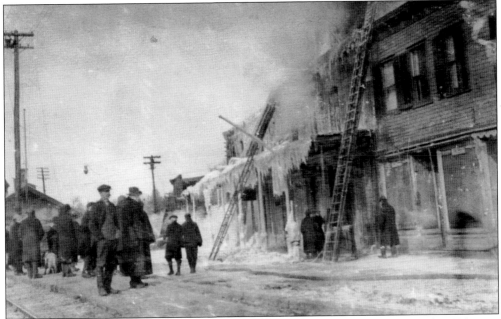

The St. Elmo Hotel was located on the site of the current post office. A fire occurred on February 1, 1920, destroying the 52-room hotel. It was owned by Robert B. Hock, the village president (mayor), and his son Fred Hock. Robert Hock died in December 1919, six weeks before the fire. During the Civil War, Hock was a captain of Company F, 12th New York Cavalry. He was taken prisoner, confined in Andersonville prison for three weeks, then transferred to three other prisons, before escaping and making his way back to Union lines. The hotel was built in 1887 and was conveniently located across from the Erie Railroad Station, now the current police station. (Courtesy of the Goshen Public Library and Historical Society.)

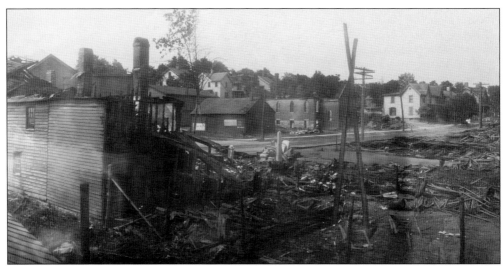

On June 23, 1909, the Sayer Lumber Company fire occurred on West Main Street. Pictured in the distance are the remains of the Olivet Chapel, today known as St. John's African United Methodist Protestant Church, rebuilt after the fire. The site of the Sayer Lumber Company is today used as a parking facility for the Suresky car dealership. (Courtesy of the Village of Goshen Historian's Collection.)

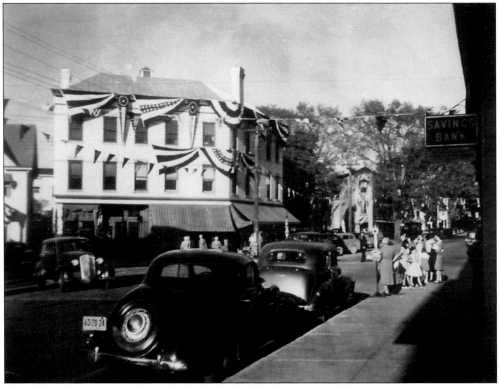

The village square is decorated and a hub of activity in preparation for the fire parade on September 27, 1941. (Author's collection.)

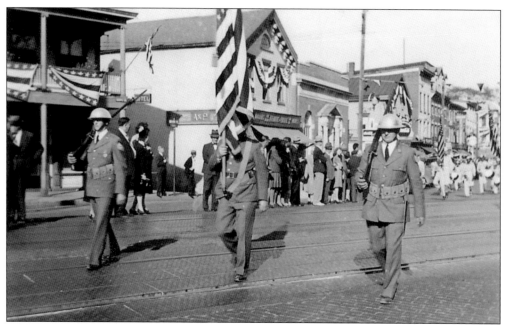

Soldiers lead the 1941 fire parade up West Main Street. The railroad tracks can be seen along the brick-paved street. The corner of the Occidental Hotel is to the left and the A&P grocery store can be seen in the background. (Author's collection.)

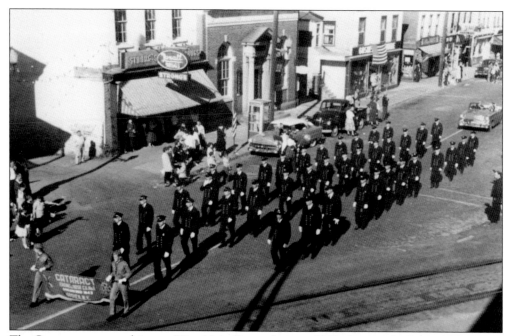

The Cataracts are marching up West Main Street during a 1950s fire parade. Strong's Pharmacy is in the building that is now the site of Baxter's Pharmacy. (Courtesy of the Village of Goshen Historian's Collection.)

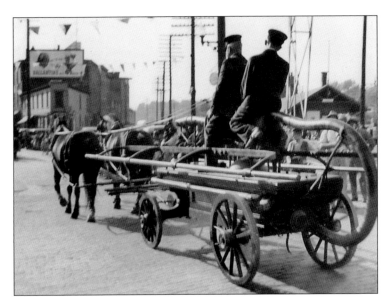

Pulled by a team of horses, the Cataract 1856 hand pumper makes its way up West Main Street. The hand pumper is still owned by the Cataracts after being restored by former captain Tom Mackey and former lieutenant Tom Lane. (Author's collection.)

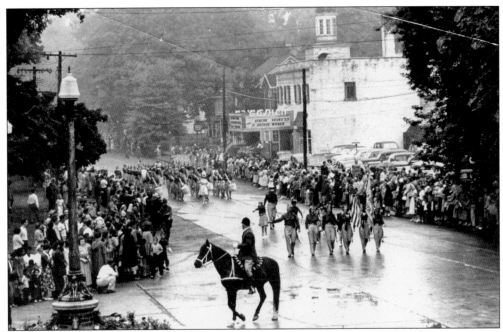

A marching band parades down South Church Street past the Goshen Theater during a 1950s fire parade. The theater was built by Carl and Walter "Wally" Neithold and opened in 1939. The theater occupied the site now used as a drive-through for the bank on the square. The marquee indicates that the double feature was *Apache Drums*, starring Lloyd Bridges, released in September 1955, and *Second Woman*, starring Robert Young, released in 1950. (Courtesy of the Village of Goshen Historian's Collection.)

Five

SCHOOL DAYS

This impressive cupola sits on what was once the Goshen Central High School, which now serves as the Goshen Middle School. Located on Lincoln Avenue and Erie Street, the building was named in 1960 in honor of Charles J. Hooker, the supervising principal from 1924 to 1960. Hooker came to Goshen in 1924. The *Times Herald Record* named him Man of the Year in 1960. (Author's collection.)

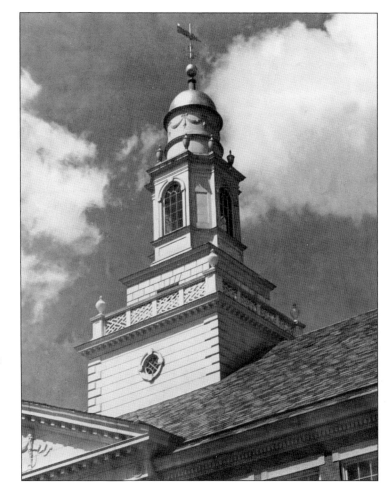

This photograph shows the center portion of what was then the Goshen High School. The school was completed in 1939 at a cost of $726,341. Previously, students attended the yellow brick school building on the corner of Main and Erie Streets. The Main Street building served as the high school from 1912 to 1940. (Author's collection.)

To the left, the columns are in place at the entrance to the auditorium of the former Goshen High School. After the new high school was built off of Scotchtown Avenue, this building became the middle school. (Author's collection.)

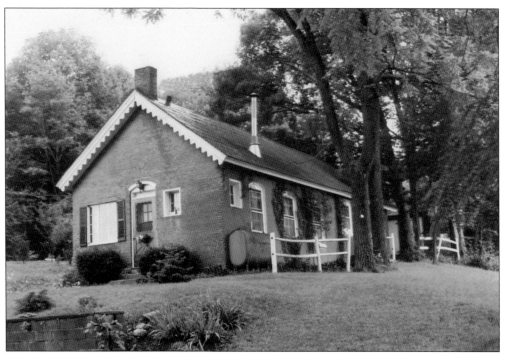

The town of Goshen had a number of one-room schoolhouses before the school system became centralized. Built around 1850, this is the only one-room brick schoolhouse in the school district. It served as the District No. 6 schoolhouse. Located on Reservoir Road, it is now a private residence. (Courtesy of the Orange County Historian's Collection.)

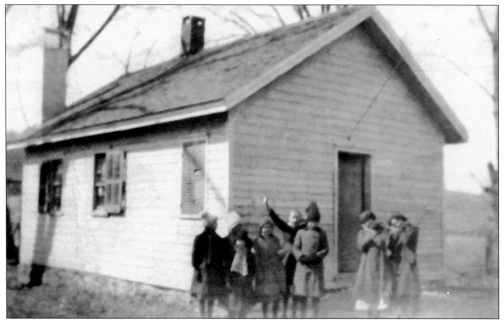

The East Division schoolhouse, located on Craigville Road, is a one-room schoolhouse that students attended before the centralization of the school district. Students pose in front of the building, which dates from around 1840 and still stands. It is now a private residence. (Author's collection.)

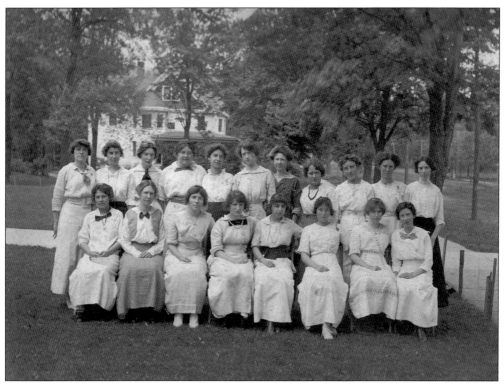

At the beginning of the 20th century, a teacher's training program was held at the Goshen High School. Seen from left to right on the lawn of the Main Street High School in 1914, the graduates of the program are (first row) Agnes Alton, Flora Freening, Ada Freening, Isabelle Connelly, Julia Knob, Dorothea Moulton, Julia Conklin, and Laura Tuthill; (second row) May Peck, Madge Seeley, Bessie Larkin, Mildred Shaw, Lizzie Johnson, Sarah Horn, Sarah Kellogg (teacher), Viola Wilkin, Katherine Doremus, and Charlotte Seacord. The house in the background was owned by the Fitzgerald family. It was demolished in the 1960s for the construction of the Orange County Government Center. (Author's collection.)

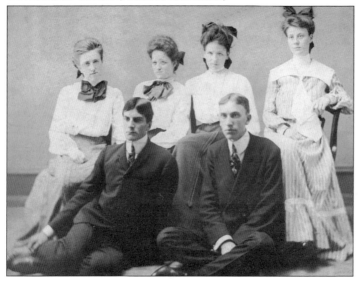

This is the 1904 graduating class of Goshen High School. The graduates, from left to right, are (first row) William Young Rumsey and Carlton Ira Smith; (second row) Anna Clara DeYor, Nellie Elizabeth Mould, Florence Seely Robbins, and Mary Elizabeth Bassett. (Courtesy of the Goshen Public Library and Historical Society.)

The Goshen High School baseball team poses for their formal photograph outside the Main Street building. From left to right are (first row) Orlando Smith and Roland Earle; (second row) Mr. Wilcox, Augustus Lippert, William Bacon, and Harry Lewis; (third row) Lester Tremper, Henry Coleman, Ralph Earle, Joe Lewis, and William Welsh. The photograph was taken sometime after 1911. (Courtesy of the Goshen Public Library and Historical Society.)

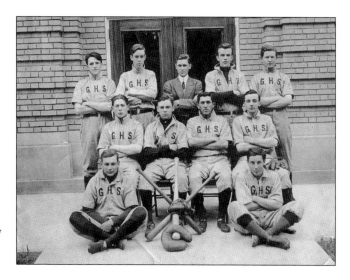

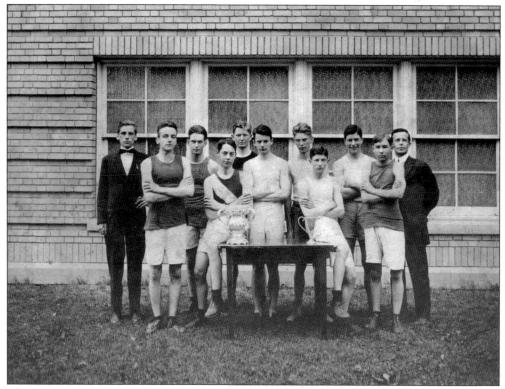

The 1914 Goshen High School track team displays their trophies outside the Main Street School. From left to right are (first row) John Hansen, Harold Houston, Van Duzer Wallace, Forrest Ivory, and Harry Lewis; (second row) Coach Thomas Tuthill, Edwin Marsden, Lester J. Roosa, William Welsh, Scott Osborne, and Manager Wayne Crosby. (Courtesy of the Goshen Public Library and Historical Society.)

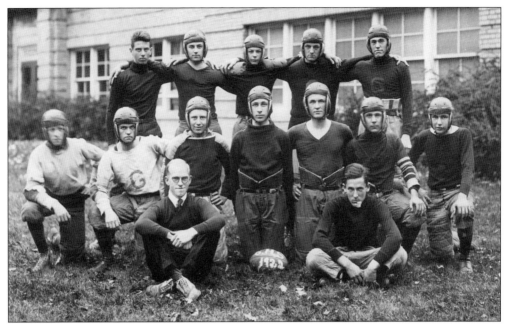

The 1922 Goshen High School football team members are, from left to right, (first row) Coach Nicholson and H. Church; (second row) W.E. ?, L. Durland, L. Reineke, A. Kipp, H. Roge, M. Cosgrove, and R. Yerg; (third row) E. Soon, R. Carpenter, J. Fraser, F. Ehlers, and E. Dikeman. The photograph predates the use of shoulder pads and facemasks. (Courtesy of Goshen Central School.)

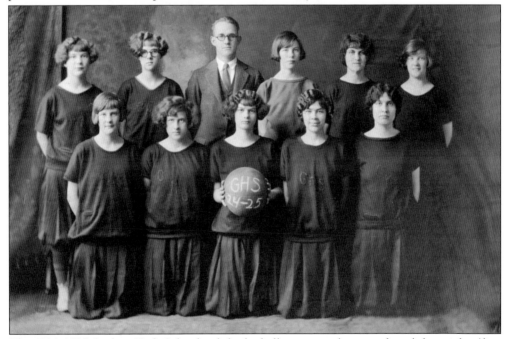

The 1924–1925 Goshen High School girls basketball team members are, from left to right, (first row) Ruth ?, Dorothy Kipp, Charlotte Coleman, Edythe Howell, and Elaine Makuen; (second row) Marjorie Green, Mildred Reevs, Coach Lyman, Ruth Scott, Gertrude Ehlers, and Mabel Van Gelder. (Courtesy of Goshen Central School.)

Six

CRADLE OF THE TROTTER

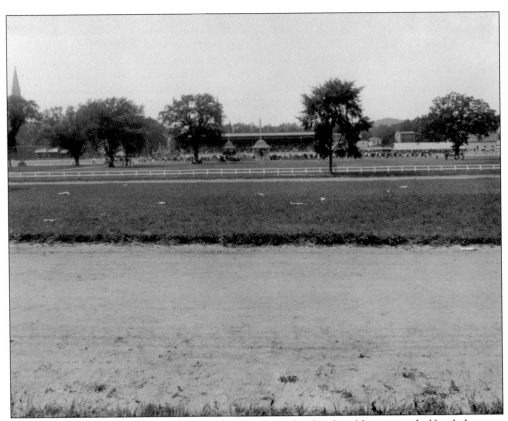

The Historic Track, seen here from Parkway, is believed to be the oldest active half-mile harness track in the United States, hosting races since the early 1830s. Richard and Thomas Edsall purchased Parkway Farm and the land in front of it. The land was used as fairgrounds and in 1855 became the site of the Orange County Fair. (Courtesy of the Goshen Public Library and Historical Society.)

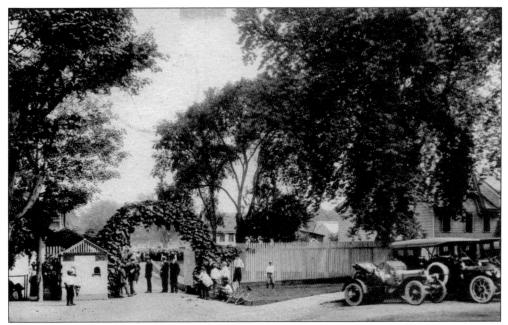

In 1854, Nathaniel Van Sickle bought Parkway Farm and the meadow and leased it to John Minchin, who built the track and operated it for a number of years. The course was only a third of a mile and was parallel to Orange Avenue. In 1862, the Agricultural Society leased the track from Van Sickle for 10 years and erected stables, fences, and stalls. In 1884, Doctor Pooler, then owner of Parkway Farm, sold the track to Joseph S. Coates. Coates rebuilt the track. He went on to a career of building and improving dozens of racetracks. (Courtesy of the Goshen Public Library and Historical Society.)

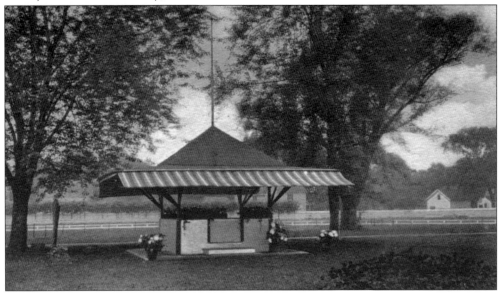

This is a photograph of the teahouse on the infield of Historic Track. The teahouse was managed by Kate Sharts, who lived in the building at the entrance to the track on Main Street and Park Place. The idea of the teahouse was to help attract ladies to the races. It became a popular attraction. (Courtesy of the Goshen Public Library and Historical Society.)

An early judge's stand is seen on the infield of Historic Track with Slate Hill in the distance. Goshen had a number of tracks before the area known today as Historic Track. In the late 1700s, racing was held on a track that was known as Fiddler's Green, a grass course in the area of South Street, Green Street, and Greenwich Avenue. Fiddler's Green was in the general area of what was to become Good Time Park, a mile track that became the site of the Hambletonian. (Courtesy of the Goshen Public Library and Historical Society.)

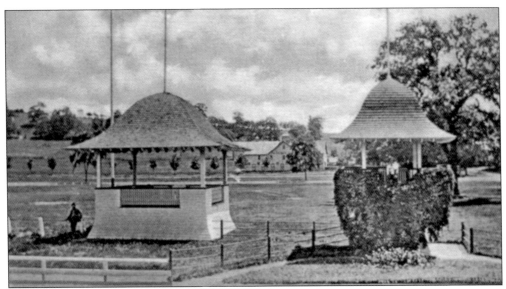

In 1911, Historic Track underwent a major renovation with a new grandstand as well as judge's stands. Another old-time Goshen track was known as the Walters course off of Route 17A in the area of the Westgate Corporate Park. Racing occurred at this site from around 1790 to 1832. The Walters course was a dirt track and considered well equipped for its time. From the early 1800s to 1832, horses were run on the Golden Hill track, a grass course in the area west of the western end of today's Golden Hill Avenue. This track was at its peak around 1810 to 1830. (Author's collection.)

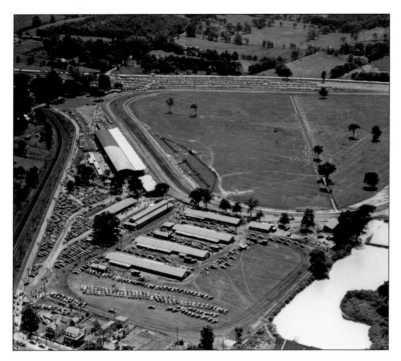

Designed by Joe Coates in 1899, the three-sided mile track, Good Time Park, was located between South Street, Green Street, and Greenwich Avenue. Pictured in this aerial photograph are the stables and the large grandstand. To the left are the old Erie Railroad tracks, now the site of the Heritage Trail. (Courtesy of the Goshen Public Library and Historical Society.)

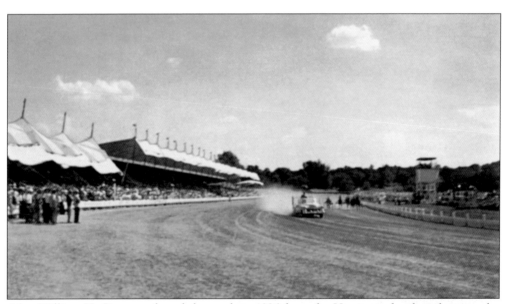

After William H. Cane purchased the track in 1926 from the Harriman family, it became the site of the Hambletonian Stakes. The Hambletonian was run at Good Time Park from 1930 to 1956. When the race left Goshen it took place in Du Quoin, Illinois, until it moved to the Meadowlands in New Jersey, where it is run today. (Courtesy of the Goshen Public Library and Historical Society.)

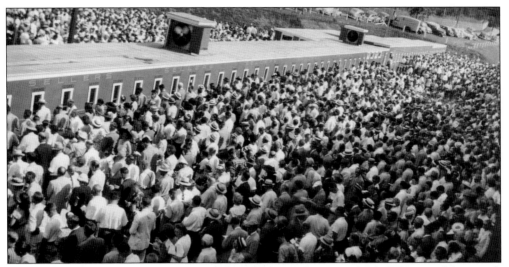

This photograph of the betting windows at Good Time Park gives an idea of the size of the crowds that attended the races at the track and visited Goshen. (Courtesy of the Goshen Public Library and Historical Society.)

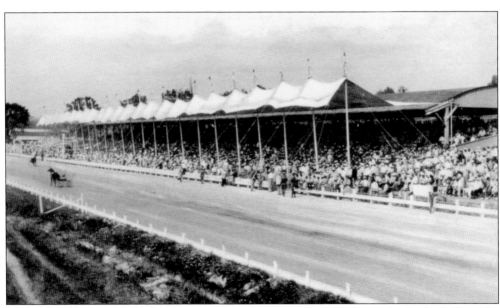

The large canopy was added to the grandstand at Good Time Park to provide shade from the afternoon sun. This photograph gives an indication that the races were well attended by enthusiastic crowds. (Courtesy of the Goshen Public Library and Historical Society.)

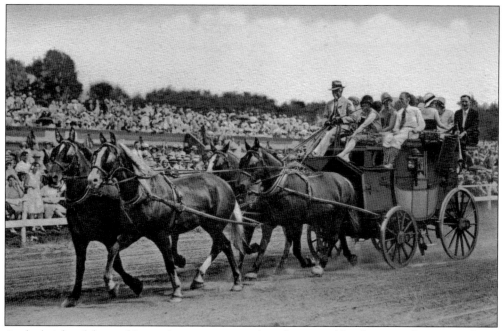

At the height of the track's popularity, a stagecoach and a team of four horses makes its way down the track at Good Time Park. (Courtesy of the Goshen Public Library and Historical Society.)

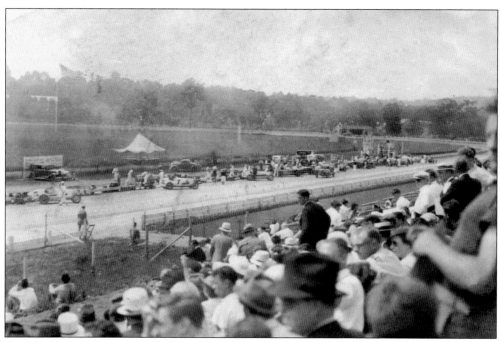

For a short time, car racing took place at Good Time Park, site of the running of the Hambletonian. Seen here, cars prepare for a race in 1936. Races also took place in 1946 and 1947. (Courtesy of the Village of Goshen Historian's Collection.)

Seven

GOSHENITES

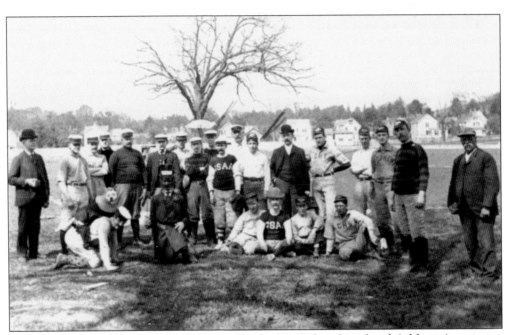

On May 13, 1903, on the infield of Historic Track, the Goshen Social and Athletic Association held a baseball game between the Bachelors, the single men of the club, and the Benedicts, the married men of the club. Pictured from left to right are (seated) Frank C. Hock (with the dog on his back), James Nicholas Van, Corwin Harwell, Patrick Martin, George Farrell, and William K. Dickerson; (standing) William S. Dayton (in derby hat), Arthur Decker, Fredrick W. Seward, Haram H. Smith, H.S. Chardavoyne, George F. Gregg, Frank Hill, Frank Larkin, Wilkin Coleman, Edward Farrell, William N. Hoffman, Peter Martin, Frank Drake, Edward J. Dikeman, J. Floyd Halstead, Harry Florence, Harvey Goodale, and Andrew J. Moore. The Bachelors won the game 19 to 12. (Courtesy of the Goshen Public Library and Historical Society.)

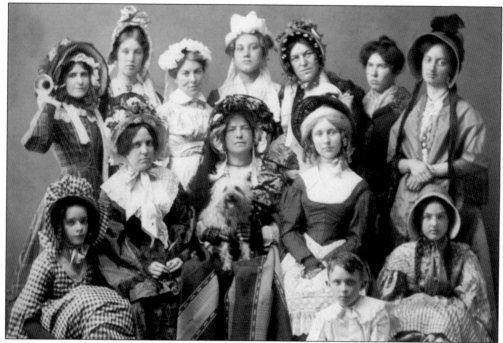

A group of local women and a boy pose after a performance of the play *Crawford*, around 1902. From left to right are (first row) Polly Alloway, Birch Bacon, Antoinette Sayer, unidentified, and Florence Thompson; (second row) unidentified, Dorothy Church, Julia Grier, Helen Duryea, unidentified, Adelaide Grier, and Laura Frost. The boy in the front is unidentified. (Courtesy of the Goshen Public Library and Historical Society.)

The Cricket Club gathered in the late 1800s. Members were Mr. and Mrs. Floyd Reevs, Mr. and Mrs. B.R. Champion, Mr. and Mrs. R.C. Coleman, Mr. and Mrs. William Murray, Mr. and Mrs. Nate Sandford. It is doubtful if actual cricket games were played. (Courtesy of the Village of Goshen Historian's Collection.)

A group of men from Goshen pose for a photograph while on a trip reported to be to Gettysburg, Pennsylvania. From left to right are (seated) William Wells (partially visible behind the tree), Jack A.J. Moore, and Jack Scott; (standing) Abe Decker, Frank C. Hock, Ira Fairchild, Fred Hock, Madden Decker, Fred Strack, James Scott Jr., and James Scott Sr. James Scott Jr. also appears on the cover of this book. (Courtesy of the Goshen Public Library and Historical Society.)

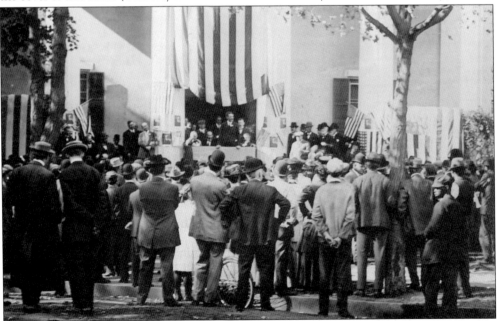

An unknown campaign rally is held in front of the 1841 courthouse on Main Street in the early 1900s. Judging from the size of the gathering, the candidate must have been popular. (Courtesy of the Goshen Public Library and Historical Society.)

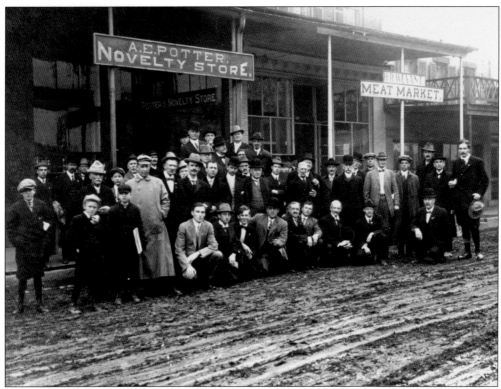

A group poses in front of Addison Earl Potter's Novelty Store on West Main Street. The site is now a vacant lot, but in the 1960s and later, it was the site of the Tavern and Jack Benny's bars. The store opened in 1887 and closed in 1907. Some of the people identified are Roswell Coleman, Dr. Fred Seward, James Donovan, Augustus C. Wallace, John B. Swezey, and Monroe Terwilliger. It is possible that this was a gathering of the Masonic Lodge, whose members met for a time on the second floor of the building. (Courtesy of the Goshen Public Library and Historical Society.)

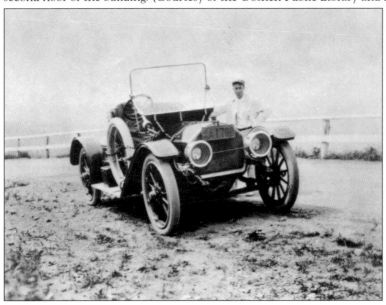

Andrew Wilson White is the proud owner of a Coates Goshen car. He was born in Goshen in 1882, married Lulu Mae White, and died in 1938. (Courtesy of the Goshen Public Library and Historical Society.)

Charles Mapes, the school crossing guard, directs traffic at the corner of Main and Erie Streets for students attending the Main Street School, now the school district's business offices. Mapes was born in Goshen on October 12, 1886, and died November 23, 1975. He served for many years as the crossing guard with his "antique" car parked nearby. He was married to Helen E. Duryea. (Courtesy of the Village of Goshen Historian's Collection.)

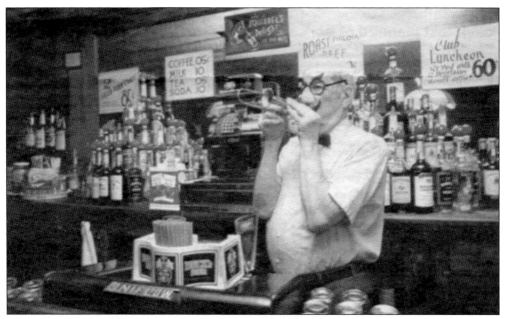

Maxwell "Max" Waldman began working at his father Ruben Waldman's New Street bar when he was 11 years old. In 1933, he took over the bar when prohibition was repealed and called it Maxwell's Steak House. Soon after, it became known as The Squirrel Cage, until new owners renamed it the New Street Tavern. Max is seen performing his classic showpiece, "Loving You Has Made Me Bananas" by Guy Marks. Max Waldman was born December 23, 1909, and died at age 80 on May 16, 1990. (Courtesy of Mike Carey, The Times Herald Record.)

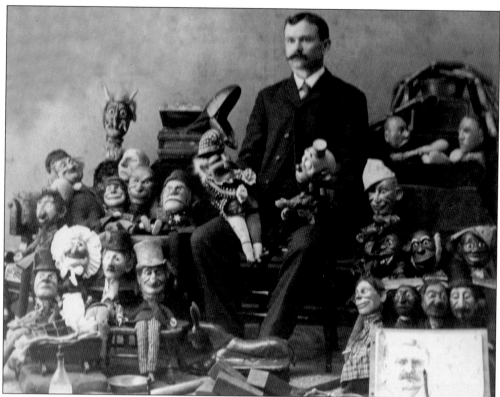

Clarence Augustus "Gus" White shows his collection of puppets, which he performed with from 1878 to 1931. The photograph also shows his skill as an artist, assuming that the sketch propped up in the lower right of the photograph is his. White was born in 1859 and died in 1934. His nephew, Harold White Sr., lived on Murray Avenue. Harold would periodically show his uncle's puppets to the public. The entire collection was sold by the Mark Vail Auction Company of Pine Bush on October 24, 1992. (Courtesy of the Goshen Public Library and Historical Society.)

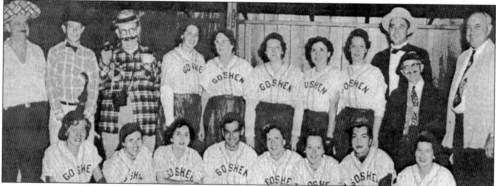

A baseball game between the mothers of baseball players, called the Bloomer Girls, versus the boys of the Goshen American Legion team occurred around 1954. Pictured from left to right are (first row) Teresa Pierce, Ann Turner, Jo Wolfe, Pete Nuzzolese, Helen Johnson, Chris Lattimer, Kay Morgan, and Thelma Dill; (second row) Chubby Mabee, Jack Frazier, John Connelly, Elanor Riverkamp, Eddie McBride's mother, Bobby Latimer's mother, Anne VanZandt, John Egbertson's mother, Mickey McMahon, Marshall Swezey, and Bob Walsh. (Courtesy of Don Riverkamp and *The Independent Republican*.)

The 1945–1946 Goshen Men's Orange County league basketball championship team members are, from left to right, (first row) Ray Schwarz, Fred Bach, Alex Fesco, Bill Kropp, Herbie Burr, and Cliff Ashman; (second row) Eddie Myruski, Gordon Ingalls, Donald Black, Warren Sherman, Ted Dunn, Don Mutchler, and Al Turi. (Author's collection.)

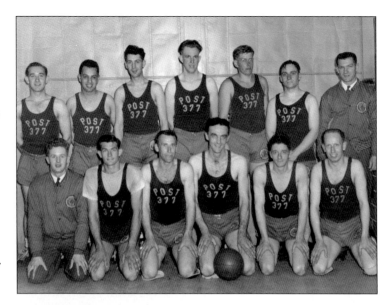

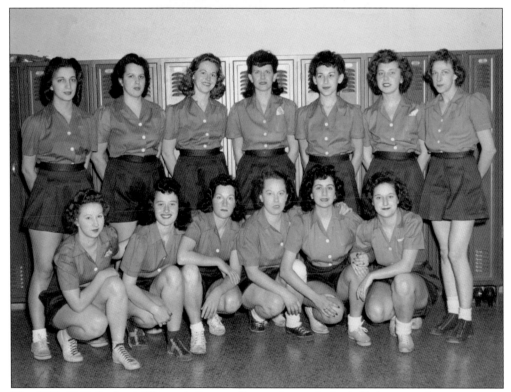

The 1945–1946 Goshen's Woman's Orange County league basketball championship team poses after defeating Otisville for the championship at a game held at the Middletown High School. From left to right are (first row) Jean Barnes, Jerry Bally (Schwarz), Ruby Burr, Julia Space, Sue Bally (Hammer), and Mim Knob; (second row) the author's mother Valerina Zabachta (Connor), Dot Space (Harrison), Connie James, Ann Knapp, Irene Myruski, Marjorie Vavricka (Carroll), and Jane Kropp. (Author's collection.)

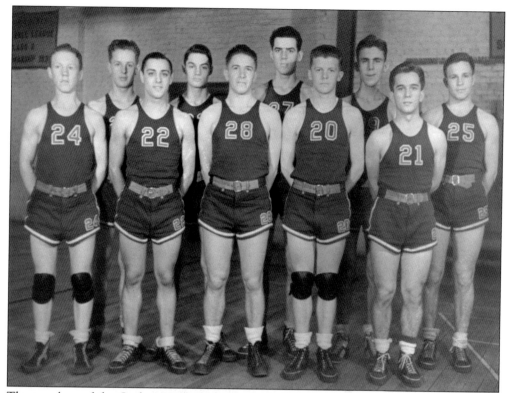

The members of the Goshen High School basketball team from about 1938 are, from left to right, Red Hartinstine, Ray Schwarz, Jimmy Cassel, Tom Lane, Harold Sitzer, Donald Black, John E. Connor (the author's father), Dino Constantino, Walt Adamkowski, and Jack Peeso. (Author's collection.)

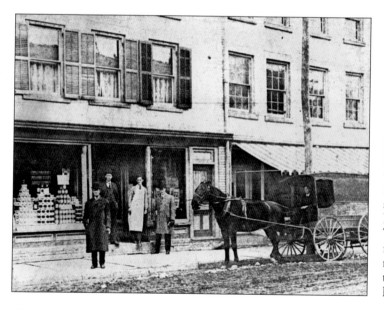

Men are seen standing in front of Scott's Grocery Store on West Main Street. The store is now the site of Linda's Office Supplies. Today, Joe Fix It's is in the store to the right. (Courtesy of the Village of Goshen Historian's Collection.)

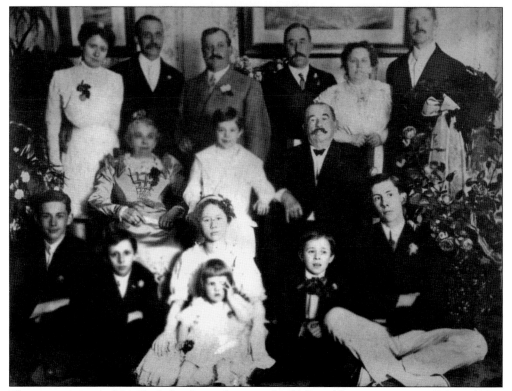

Three generations of the Hock family are shown at the 50th wedding anniversary of Mr. and Mrs. Robert B. Hock at the family-owned St. Elmo Hotel on June 16, 1911. Pictured from left to right are (first row) grandchildren Clarence Vail, Robert Bruce Hock, Catherine Vail with Virginia Vail in front, Fletcher Hock, and Harold Hock; (second row) Mrs. Robert B. Hock, Richard Vail, and Robert B. Hock (village president or mayor); (third row) Mr. and Mrs. Robert J. Hock, Frank Hock, Fred Hock, and Mr. and Mrs. Clarence Vail. Mrs. Vail was the daughter of Mr. and Mrs. Robert Hock. (Courtesy of the Village of Goshen Historian's Collection.)

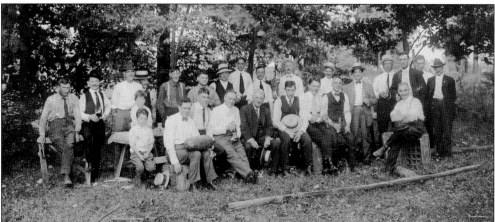

Pictured here are the employees of the Ballantine Brewery warehouse located on the corner of North Church Street and St. John's Street. The building later became known as the Odd Fellows Hall and is currently a bank. Note all the beer crates and that nearly everyone in the photograph has a bottle in their hand. (Courtesy of the Village of Goshen Historian's Collection.)

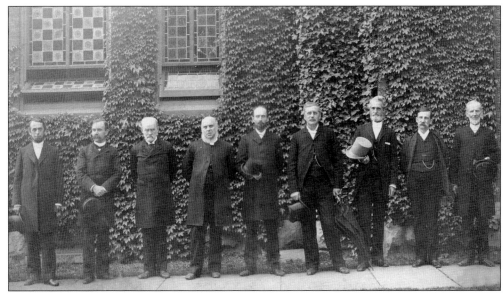

In 1891, on the seventh anniversary of the new church building, members of the Goshen United Methodist Church pose outside the church on Main Street. From left to right are John Greenleaf Oakley, William S. Winaus, Thomas Lamont, J.K. Nardle, four unidentified, and Elias S. Osborn. The Goshen United Methodist Church was built in 1884 after moving from its former location on North Church Street. (Courtesy of the Goshen Public Library and Historical Society.)

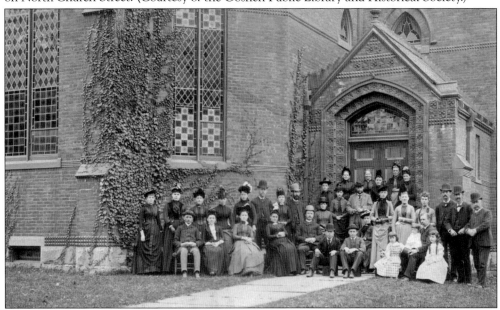

Members of the congregation gathered in front of the Goshen United Methodist Church on Main Street. Members pictured are William Bronson, Frank Ford, Mr. Willaim Winaus and children, Frank Doremus, Carrie Doremus, Ida Higgs McCoy, Mrs. John Farrell, Kitty Doremus, Mary Donnelly, Mrs. Kate Wood, Mrs. Winaus, Luaken Bush, William McNeice, A.G. Wheeler, Fannie McClellan, Mary Ackerly, Emma Doremus, Fannie Vreeland, Miss Vail-Hill, Sam Crosby, John Donnelly, Jessie Doremus, Floyd Reevs, Minnie Fuller, Mrs. Simon Gillespie, Mrs. Fuller, Mrs. O'Neil, Mrs. Smith, and Mrs. Deyo. (Courtesy of the Goshen Public Library and Historical Society.)

Eight

GOSHEN GONE

This large Victorian was a Coates family home located near where Harriman Drive is today. It was bought by Arthur Coates, the brother of Joseph S. Coates, who came to Goshen in 1897. Together, they were involved in the manufacturing of racing sulkies at the Miller Cart Company on West Main Street. They later operated the Coates-Goshen automobile factory on Greenwich Avenue. Arthur Coates was married to Mary Robinson. They had three sons. Arthur died on January 8, 1930. A photograph of the rear view of the house can be seen in Images of America: *Goshen*. (Courtesy of Adele Coates.)

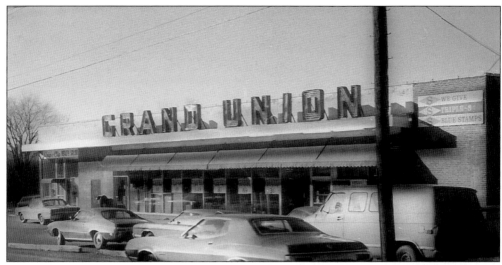

Considered very modern by the standards of the day, the Grand Union was in the building on West Main Street that is now the site of an auto parts store. Before construction of this new store, the Grand Union was in the former Goshen Hardware building on West Main Street. The store featured slanted chutes where the canned goods could be selected and filled by workers from behind a wall. The store also had automatic doors, a new feature for the time. (Courtesy of the Goshen Public Library and Historical Society.)

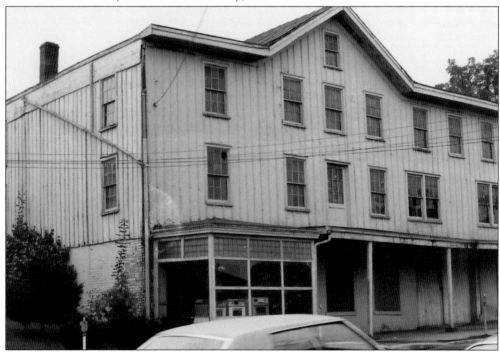

Once located on the corner of West Main and High Streets, this building began as a carriage factory and later became a storage building for the furniture and funeral business of W.D. Van Vliet and Son. Their main place of business was in the flat-iron building that was on the corner of Main Street and Webster Avenue. This site is now a vacant lot. (Courtesy of the Orange County Historian's Office Collection.)

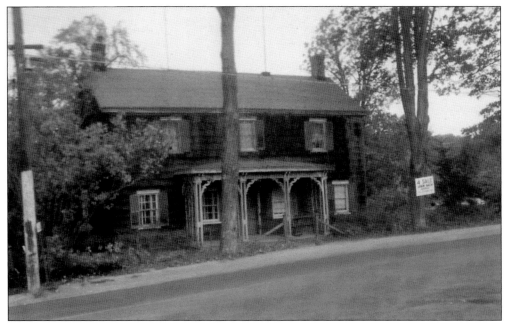

The Coleman house once stood on West Main Street across from the McBride trucking company, now a condominium complex. At the beginning of the 20th century, it was the home of Mary Mapes Wardrop, originally from Monroe. She died in 1913 at the age of 75. The site is now a vacant lot. (Courtesy of the Village of Goshen Historian's Collection.)

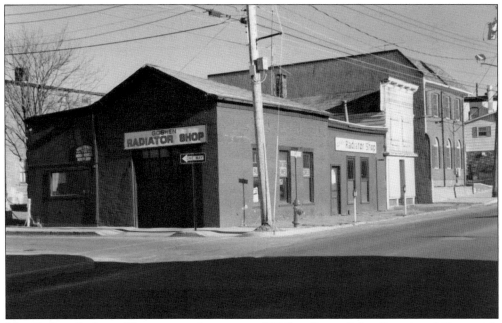

The Goshen Radiator Shop was on the corner of Walker Street (John Street) and Greenwich Avenue. (Author's collection.)

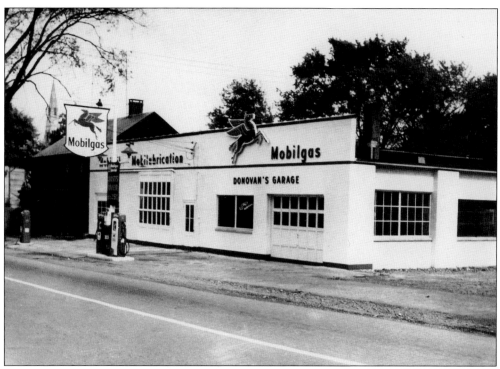

Donovan's Garage, once located on Greenwich Avenue, is now a beer distributor and bagel shop. (Courtesy of the Orange County Historian's Collection.)

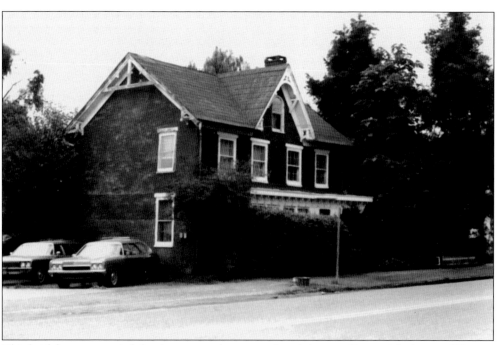

This brick house occupied the site next to the current bagel shop on Greenwich Avenue. The site is now a vacant lot. (Courtesy of the Orange County Historian's Office Collection.)

These houses along Greenwich Avenue occupied the site that is now used as a car lot for the Healey car dealership. (Courtesy of the Village of Goshen Historian's Collection.)

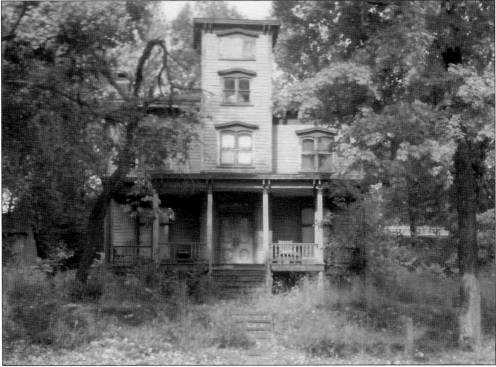

Owned by J.J. Payne in 1875, this Victorian house was located on Greenwich Avenue, now a vacant lot adjacent to two houses on the corner of High Street that are now offices. The lot is directly across the street from the Healey car dealership. In the early 1900s, the house belonged to the Samuels family. The house was condemned in 1964 and was removed by the Goshen Fire Companies. (Courtesy of the Village of Goshen Historian's Collection.)

Today known as Railroad Avenue, these buildings stood on Greenwich Avenue and the Erie Railroad tracks. Today, the Dickerson and Meany building occupies the site of the building on the left, and offices now occupy the site of the building on the right. Around 1900, both buildings were owned by James Kane. (Courtesy of the Goshen Public Library and Historical Society.)

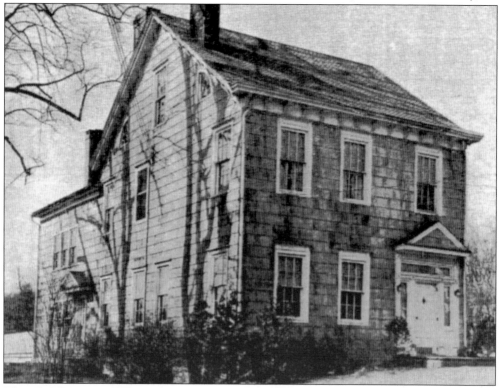

This 1848 house on Webster Avenue was the Merriam residence for decades. Henry Merriam was born in Schaghticoke on December 1, 1802. He married Ann Eliza Reevs on January 1, 1833. Ann was the granddaughter of Col. Benjamin Tustin, a Revolutionary War officer who was killed at the Battle of Minisink in 1779. Merriam was a partner of John Smith and operated a tinware manufacturing business and store. He died in Goshen on February 26, 1898. In the late 20th century, the house was owned by the Brinkley family. The house was destroyed by a fire on Monday, May 24, 2007. (Courtesy of Mildred Parker Seese.)

Pictured in the distance on the left is Baker's Lounge, now the site of the Cataract Engine and Hose Company firehouse. William "Bill" Baker was born in 1928. Bill was active in high school sports and went on to play semipro football for the Franklin Miners and the Newark Bears. He operated his Green Street bar and restaurant for many years. He died on January 4, 2011. (Courtesy of the Goshen Public Library and Historical Society.)

Today, John Street is known as Walker Street, named in honor of police chief Fredrick Walker. The building to the left still stands today, as well as the building in the distance. The three buildings in the middle of the block were various businesses over the years, including Wehinger's grocery store and Shesa's Dry Cleaning business. The three buildings in the center have been razed, and the area is now vacant. (Courtesy of the Goshen Public Library and Historical Society.)

This is a photograph of the Florida Road/Route 17A just leaving the village of Goshen. The Steward house was on the right. The picket fence that surrounded the house can be seen. Today, the Westgate Corporate Park is on the right. (Author's collection.)

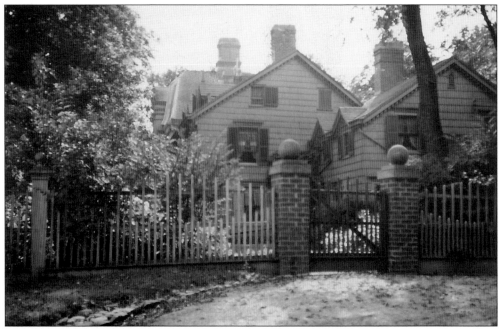

The Steward family house is pictured here in August 1942. The original part of the house was built in 1744, with the larger section built in 1865. The house was demolished in the 1960s to make way for the Sorrento Cheese Company plant. (Author's collection.)

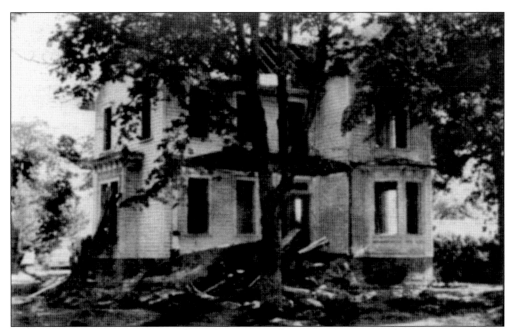

This Victorian was once located on the corner of Orange Avenue and Main Street. It was demolished to make room for the bank that now occupies the site. The house was owned by the Hartford family at one time. (Courtesy of the Village of Goshen Historian's Collection.)

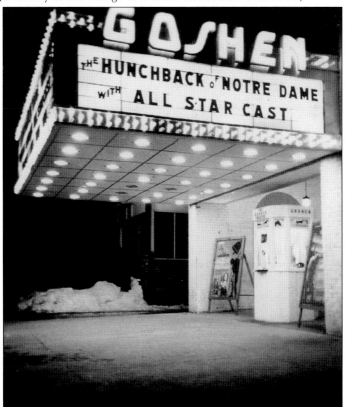

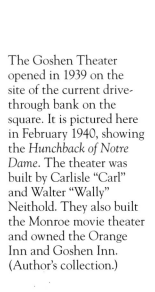

The Goshen Theater opened in 1939 on the site of the current drive-through bank on the square. It is pictured here in February 1940, showing the *Hunchback of Notre Dame*. The theater was built by Carlisle "Carl" and Walter "Wally" Neithold. They also built the Monroe movie theater and owned the Orange Inn and Goshen Inn. (Author's collection.)

DISCOVER THOUSANDS OF LOCAL HISTORY BOOKS
FEATURING MILLIONS OF VINTAGE IMAGES

Arcadia Publishing, the leading local history publisher in the United States, is committed to making history accessible and meaningful through publishing books that celebrate and preserve the heritage of America's people and places.

Find more books like this at
www.arcadiapublishing.com

Search for your hometown history, your old stomping grounds, and even your favorite sports team.

Consistent with our mission to preserve history on a local level, this book was printed in South Carolina on American-made paper and manufactured entirely in the United States. Products carrying the accredited Forest Stewardship Council (FSC) label are printed on 100 percent FSC-certified paper.

MADE IN THE USA